THE PAINTER'S EYE

Learning to Look at Contemporary American Art

Roy Lichtenstein, *Reflections: Art*, 1988, oil and magna on canvas, 44¼″ × 76¼″.
Leo Castelli Gallery, New York. © Roy Lichtenstein/VAGA 1990 New York.

THE PAINTER'S EYE

Learning to Look at Contemporary American Art

JAN GREENBERG AND SANDRA JORDAN

Delacorte Press

Every effort has been made to contact the original copyright holders of the material included.

page 25. Interview conducted by Robert Enright for *Border Crossings* magazine, Volume 8, Number 4. Winnipeg, Canada, 1989.

page 43. "My Painting" from *Possibilities I. Winter*. New York, 1947–48.

page 44. "*Number 1* by Jackson Pollock (1948)" by Nancy Sullivan, first published in *Ramparts* magazine.

page 54. "To Morris Louis of the Blue Veil, 1958–59" by Anne Chernay, published in *The Poet Dreaming in the Artist's House: Poems About the Visual Arts*, Emilie Buchwald and Ruth Reston, editors. Minneapolis, Minn.: Milkweed Editions, 1984.

pages 60 and 61. Interviews from *Originals: American Women Artists* by Eleanor Munro. New York: Touchstone/Simon and Schuster, Inc., 1982.

page 79. *The Philosophy of Andy Warhol (from A to B and Back Again)* by Andy Warhol. Orlando, Fl.: Harvest/HBJ Book/Harcourt Brace Jovanovich, 1975.

Credits for photographs of works of art appear on pages 90 and 91 in the list of paintings.

Photographs of the artists: page 6, © Hans Namuth 1968; page 14, © Tseng Kwong Chi, courtesy Vrej Baghoomian Gallery; page 17, courtesy Audrey Flack; page 28, © 1986 Bob Adelman; page 34, © Hans Namuth 1966; page 42, © Hans Namuth 1950; page 49, © Gianfranco Gorgoni, courtesy Leo Castelli Gallery; page 56, © Marina Schinz; page 59, © Hans Namuth 1987; page 60, © Eric Boman, courtesy Paula Cooper Gallery; page 66, © 1990 Gregory Conniff, courtesy Middendorf Gallery; page 70, © Hans Namuth 1980; page 73, courtesy Donald Sultan; page 79, © 1980 Barbara Goldner.

Copyright listings for the paintings appear on pages 90 and 91.

Published by
Delacorte Press
Bantam Doubleday Dell Publishing Group, Inc.
666 Fifth Avenue
New York, New York 10103

Library of Congress Cataloging in Publication Data
Greenberg, Jan [date of birth]
The painter's eye : learning to look at contemporary American art /
by Jan Greenberg and Sandra Jordan.
p. cm.
Includes bibliographical references and index.
Summary: Introduces ways of seeing, experiencing, and appreciating
art through the examination of contemporary American works.
ISBN 0-385-30319-X
1. Painting, American—Juvenile literature. 2. Painting, Modern—20th century—United States—
Juvenile literature. 3. Painting—Appreciation—Juvenile literature. [1. Painting, American.
2. Painting, Modern—20th century. 3. Art appreciation.] I. Jordan, Sandra (Sandra Jane Fairfax) II. Title.
ND212.G74 1991
701'.1—dc20 90-44877 CIP AC

Manufactured in Italy
June 1991
10 9 8 7 6 5 4 3 2 1

To Ronnie, Lynne, Jeanne, and Jackie, with love
J.G.

To Robert Verrone, in memory, with love
S.J.

ACKNOWLEDGMENTS

Many people helped us at various stages of this book. Some talked or wrote only to one of us, but in every case we both are grateful. Without them, there would not have been a book.

Richard Anuszkiewicz, Audrey Flack, Sam Gilliam, Ellsworth Kelly, Roy Lichtenstein, James Rosenquist, Frank Stella, Donald Sultan, Wayne Thiebaud, and Tom Wesselmann for generously and thoughtfully taking the time from their crowded schedules to answer questions.

Emily Rauh Pulitzer, Ann Beneduce, and Jeanne Greenberg, who read the book in manuscript and made valuable suggestions.

Laura Gritt at Leo Castelli Gallery; Julie Graham at Paula Cooper, Inc.; Maxwell Davidson Gallery; Marvin Ross Friedman; the Greenberg Gallery; and the Middendorf Gallery for their cheerful assistance in finding artists, photographs, and information.

Jerilynn Changar, Ph.D., Art Education Consultant; Carole De Sandro of the Museum of Art, RISD, Providence, Rhode Island; Robert Duffy, Features and Arts Editor, *St. Louis Post-Dispatch*; and Muriel Silberstein-Storfer of the Doing Art Together program at the Metropolitan Museum in New York for talking about the programs and sharing their expertise.

The Students of the Central Visual and Performing Arts High School, St. Louis, Missouri.

George Nicholson of Dell/Delacorte, without whose infectious enthusiasm and interest we never would have begun to write this book; David Gale, who tactfully and patiently edited and coordinated; and Kathy Westray, the designer, who translated a manuscript and photographs into a book.

And Judith Aronson, Ph.D., a pioneer in Aesthetic Education, for her early encouragement.

Willem de Kooning in his studio.
(© Hans Namuth, 1968)

CONTENTS

PREFACE

The Painter's Eye introduces a way of seeing and experiencing art. Think of this book as several voices, yours and ours, having a conversation, asking questions. What makes a painting work? What is the artist trying to communicate? What is the feeling expressed? Sometimes the answers are not easy. At first, whether we find a particular painting beautiful or interesting or disturbing may be subjective, a matter of personal preference. It has to do with the memories, feelings, and ideas we bring to a work of art. But there is a common vocabulary of art that we can explore together.

Art is universal. The barriers of language, time, and culture crumble in a moment of looking. We can guess at the lives of people who inhabited caves a thousand years ago; we cannot know. Yet their paintings left on cave walls still delight our eye. Although we will focus on contemporary painting, the same language can be used to talk about *all* art from these cave paintings to the most up-to-the-minute painting on a New York SoHo gallery wall. The elements of color, line, shape, and texture and the principles of organization remain constant. What changes are the ways these visual effects are used—from century to century, from artist to artist. By learning something about these constants, the most basic vocabulary of art, we come to all paintings with greater understanding.

We all draw when we are young. Then we learn to read and write, add and subtract. After that the writer tells us in words, the mathematician in numbers. But for a few, the artists, the way we once shared of organizing our view of the world remains the chosen method of commu-

nication. The mature work of the artist bears as much resemblance to those early efforts as our first lisped baby words do to a sonnet. Yet the roots of a shared experience are there.

The more we worked on this book, the more we wondered, What makes a painter? Why do some people continue to explore their world visually? Curious, we asked some painters about their early encounters with art. You'll read their varied replies scattered throughout the book and also see some photographs of them at work.

We concentrated on contemporary American paintings for many reasons. Not only are they accessible to us and to you, but also we like the idea of art that is happening now in our own time and culture. We have chosen works that represent many diverse trends in American art since World War II. Some are by famous artists; others, by artists who are less well known. All are paintings we find intriguing. Many celebrate color or shape or line without reference to a recognizable image, thus highlighting certain points we wanted to illustrate in the text. You can find works by these painters and many others in museums and galleries, as well as in private collections, shopping malls, corporate headquarters, and even airports or on building walls across the country.

In fact, today you see new art everywhere. Sometimes it is talked about so much on television, in the newspapers, and in magazines that the razzle-dazzle of art world publicity interferes with our ability to see it. We wanted to perceive works of art removed from the distraction of dollar signs; to consider individual paintings, not the artist's reputation.

After a year of writing and talking we still enjoy looking at art to-

gether, sharing ideas and opinions. We usually like the same paintings, but sometimes we like them in different ways. Jan's reactions are often poetic, physical, or musical. She might say, "How would you move like the line in that painting?" Sandra responds psychologically, meta-phorically, and with her camera. A day spent in the museum can end with her taking photographs.

Making art yourself is another satisfying extension of looking at paint-ing. At the end of this book you'll find a list of other books that give a hands-on approach to art. There is also a brief historical perspective of the artists we have included, as well as a glossary of art terms and other useful information. Keep in mind that the reproductions of artworks in this book are very different from the originals in terms of size, texture, and color. In fact, some of the works are three-dimensional and a flat photograph cannot do them justice. There is no substitute for seeing a real painting, so we encourage you to visit museums and to discover art in your everyday settings.

At last everything comes back to the mysterious and wonderful mo-ment when you fall under the spell of one special painting, understand it in a way that is beyond words, a visual connection that is its own explanation. The artist Donald Sultan (see p. 87) talked about such a moment in his own life:

"When I was a child I was taken by my parents to the Ringling Museum in Sarasota, Florida. I was eleven years old. We wandered the grounds and looked at the large classical theme pictures: soldiers,

Roman armor, naked ladies and the like. I thought they were all pretty much the same. Then we moved to the circus museum and I stood staring at a picture, 'The Giant.' My mother told me that when she was a little girl, she sat on that giant's knee, and that his finger ring was so large that she could pass a fifty-cent piece right through it. It was at that moment that the art and the magic merged and I decided to be an artist myself."*

Another artist, Frank Stella (see p. 84), described a similar time when "art and magic" merged:

"I have a vivid memory of an incident that occurred in the fourth grade. A visiting art teacher came to our room to help with preparations for Thanksgiving. With colored chalk she drew a big turkey on the blackboard. It seemed to happen so quickly. The image appeared as if driven by magic from the teacher's hand. Even today that slightly faded turkey seems enchanted."

The aim of art is to provide an experience, be it joyful or disturbing. But the ability to enter the experience is up to you. As you meet the artists and their works in these pages, we hope you will be captured by *their* special "magic" and continue the dialogue.

* Quotes by artists, unless otherwise noted, come from interviews and correspondence with the authors.

FIG. 1. Jean-Michel Basquiat, *Made in Japan,* **1982, oilstick and acrylic on canvas, 60″ × 36″.**
Greenberg Gallery, St. Louis.

1

NEW ART AND FRANKENSTEIN'S MONSTER

You walk into a gallery and find yourself face-to-face with Franken-
stein's Monster!

Hanging on the wall is a big painting covered with odd shapes
and designs, squiggles and splatters, slapdash strokes of paint running
every which way around the canvas (FIG. 1: *Made in Japan* by Jean-Michel
Basquiat). Like the monster, this work is wild, even bewildering.

I don't get it, you say to yourself. What's that supposed to be? At times
contemporary art seems to be about nothing at all—one large square of
white, or lines of colors zigzagging across the canvas, or a series of
brightly colored rectangles that look happy or exciting for no apparent
rhyme or reason. But there is a reason. To discover what it is involves
looking with a responsive eye.

The following conversation was overheard in The Museum of Modern Art in New York. But similar dialogues are played out in other museums every day.

Two people stopped in front of *Triple Elvis* (FIG. 2) by Andy Warhol.

Person One: "That's just a big photograph of Elvis Presley blown up and painted over. Anybody could do that. I could do that."

Person Two: "Look at Elvis! He really was the King!"

And they moved on. They looked at the painting and identified the subject matter. They even had an emotional response to it. But could they have said more? Was there anything else to say? Well, yes! What you say after you say, "I like it!" or, "I don't like it!" is what this book is all about.

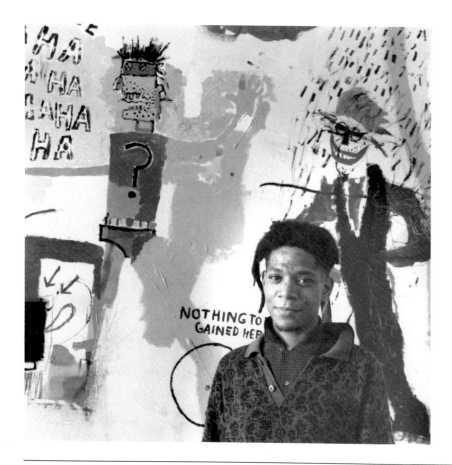

Jean-Michel Basquiat in front of one of his graffiti-paintings.
(© Tseng Kwong Chi)

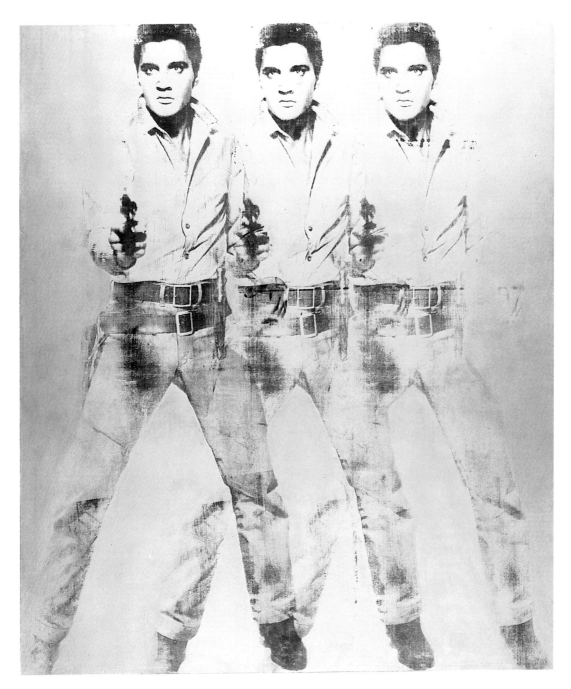

FIG. 2. Andy Warhol, *Triple Elvis*, 1962, silk-screen ink on aluminum paint on canvas, 82″ × 60″. Virginia Museum of Fine Arts, Richmond.

NEW ART AND FRANKENSTEIN'S MONSTER

What makes a painting work? To find out, ask yourself a few questions. Do I like it? Now go further. What do I see? How is the work composed? What is the feeling expressed in the painting? How does it make me feel?

To answer these questions, we will discuss some contemporary American paintings step by step, one part at a time, until we finally discover the meaning of the painting through the language of art.

First we look at a painting. Is it a picture of a man or a field of poppies or a series of lines and circles? Describe it, using only the information you can see.

Next, view the painting in terms of the elements of art: line, shape, color, and texture. The way an artist defines the basic elements, combines them, uses them, or omits one or more of them is what makes a work of art unique. Audrey Flack, an American artist who paints still lifes in photo-realistic detail, talks about the development of *her* unique artistic vision:

"When I was a student, I would set up problems for myself. Once, while I was making a watercolor, it started to rain. I wanted to capture the rain. I held my almost completed drawing out of the window and let the raindrops splash on it, thinking, What could be more real than the raindrops themselves? Before my very eyes, the rain washed away the watercolor. I was left with a blur. An artist has to re-create nature, restructure it, go beyond it. Rain is rain, but a painting of rain is different."

And of course, the way in which each artist sees rain, imagines rain, experiences rain, and paints rain is different, too. These differences in perception also are expressed through certain visual effects: rhythm, balance, variety, emphasis, spatial order, and unity. Through these principles of design, the artist organizes the elements into a unified whole. For example, in *Made in Japan* a variety of lines form repeated patterns and rhythms. In *Triple Elvis*, Warhol chose to portray Elvis's image three times, as well as to emphasize a silvery background. The artist's decision to repeat or emphasize affects our response to an artwork. We ask, "How is the painting organized?" Our answer depends not only on the artist's skill at solving visual problems but also on our making sense out of what we see.

And that brings us to the last and most important step: the expressive quality of the artwork. What meaning is expressed through the artist's use of line, shape, texture, and color? What do

you think the artist is trying to say about his or her vision of the world?

The expressive quality in art can be taken even further by asking, "What feeling does the work communicate?" There are some imaginative ways to interpret a painting, to re-create an artwork, bypassing your "reasonable" or "logical" responses, through movement, poetry, storytelling, or music.

Looking at a painting can be like solving a puzzle. All the parts fit together to make a unified whole. When you have figured out what's going on inside the work of art, you will come closer to something deeper: the real aesthetic concerns of the creator of art and the means he or she has chosen to express them. And then ask yourself again whether or not you like the painting. You might not have changed your original judgment, but now you will be able to defend your opinion in the language of art. If you keep an open mind, you may find that Frankenstein's Monster is not a beast after all but a beauty.

Audrey Flack working on a painting.

2

THE LANGUAGE OF ART

Let's begin with this still life of five hot dogs (Wayne Thiebaud: *Five Hot Dogs* FIG. 3). Notice the label. It contains some important information. In addition to identifying the artist, Wayne Thiebaud, and giving the title, *Five Hot Dogs*, the label tells when it was painted, 1961, the size, 18″ × 24″, and the material of the painting, oil paint on canvas.

What do we see? The first step is to describe only what we know is there. At the start we see five hot dogs lined in a row on a white background—a simple, straightforward image of an ordinary subject. But when we look closely, each hot dog is a little different, from the one on the left with a big dollop of mustard to the last, more elongated sandwich. The dark lines on the hot dogs could be marks made by their being turned on a grill. The shadows of the buns give an impression of three dimensions, as if we could reach out and pluck one right off the canvas.

Sensory words describe qualities in a painting that remind us of things we can touch, taste, see, hear, or smell. Here are some sensory words that come to mind when we look at *Five Hot Dogs*: *succulent, stark, angular, curvy, soft,* and *savory*. We will refer back to *Five Hot Dogs* until we have discovered clues that will reveal the meaning or expressive quality of this provocative work.

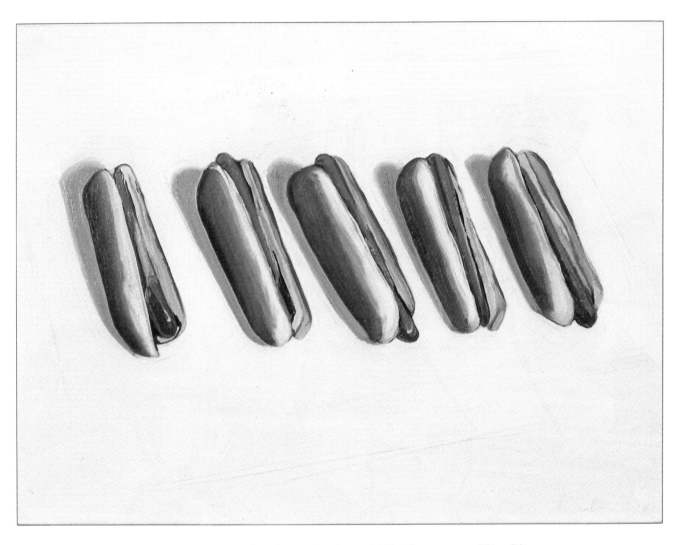

FIG. 3. Wayne Thiebaud, *Five Hot Dogs*, 1961, oil on canvas, 18″ × 24″.
Collection of John Bransten, San Francisco.

The second step is to see how artists use the elements of painting: line, shape, texture, and color. These are the basic parts, used by artists in many different styles, media, and methods. They are a vocabulary for creating a work of art and for talking about it, not rules for artists to follow. While we can consider color or line separately, the elements of a painting work together. So sometimes our discussion of the elements overlap.

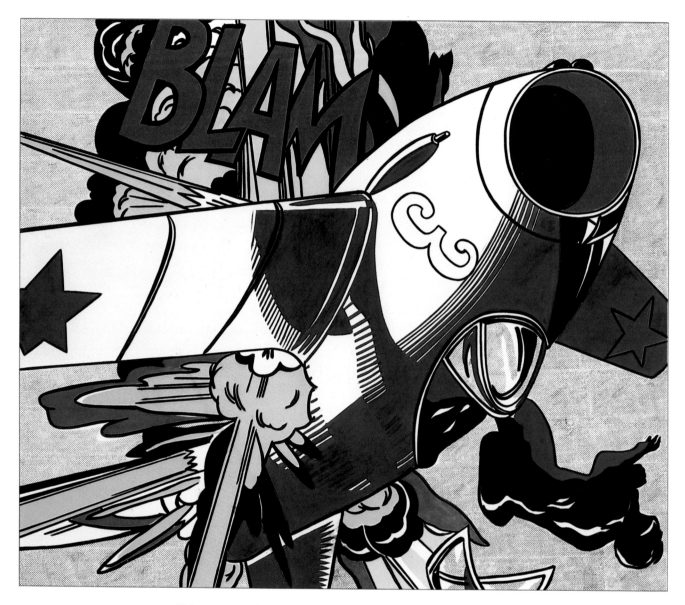

FIG. 4. Roy Lichtenstein, *Blam*, 1962, oil on canvas, 68″ × 80″.
Yale University Art Gallery, New Haven, Collection of Richard Brown Baker.

THE PAINTER'S EYE

LINE

The mark your pencil leaves on paper is a line. An artist uses tools, such as a brush, a palette knife, or even his or her finger, to make a line in paint on a canvas. These lines may outline a figure or a shape and form a letter or a number, as well as connect one shape to another. Yet a shape or a line can be indicated without an actual mark being drawn. Line also refers to the edge of a shape or the place where two colors meet. For example, a line is visible at the seam where a red square and a blue square touch.

But line does more than define the outlines of things. It also shows movement and direction. Lines are vertical, diagonal, straight, thick, thin, long, short, jagged, and smooth, and that's just the beginning. Each of these lines conveys its own mood to the viewer. Vertical lines can be seen as strong, rigid, formal, or even religious. Horizontal lines can be interpreted as peaceful, depressed, or serene. Jagged lines may indicate excitement, anger, or energy. Curved lines often are sensuous, organic, and rhythmic.

In *Blam* (FIG. 4) by Roy Lichtenstein a fighter plane explodes; a figure tumbles from the cockpit. Surrounded by lines speeding out in every direction, the red letters *BLAM* provide an immediate focus. Bold black lines enclose the colorful shapes. One line leads to another, providing continuous movement. The lines are made with a brush, but the artist leaves no trace of his brushstrokes. The surface is flat; the dots are enlargements of the Ben Day process of commercial printing. When a violent subject is outlined in black, flat and precise in the style of a comic strip, the artist, as well as the viewer, becomes distanced from the violence. American artists, such as Roy Lichtenstein and Andy Warhol, responded to the instant replay of war and crime portrayed over and over on TV. Popular culture, including advertising and the media, provided subjects for these pop artists.

Roy Lichtenstein's idea, enlarging cartoon images into paintings, came from making drawings for his children of Mickey Mouse and bubble gum wrappers. His pop art paintings of the 1960s, along with his more recent works, inspired by art of the past, provide a strong visual impact. When asked why he became an artist, Lichtenstein said,

"I was interested in the nature of the activity that generated art. Why could a few marks by one person be so much more important than a few marks by another person? What kind of activity engenders meaning from these marks? It was the pursuit of this puzzle that propelled me (just to introduce some alliteration) to study art."

All you can see initially in *Number 1, 1950* (FIG. 5) by Jackson Pollock is a canvas of energetically curving lines. It is an abstract painting, which means no recognizable image is stressed. *Number 1* is also known as *Lavender Mist*, because at a distance the swirling layers of ivory, silver aluminum, pale turquoise, and rosy pink lines blend into a haze of lavender. A sense of movement is achieved by lines crisscrossing the surface of the canvas. The lines crackle with energy, the artist's involvement clearly visible. They appear random, but as we look, patterns emerge. The artist made this painting by spreading an unstretched canvas on the floor of his studio. He moved around it like a dancer, pouring, dripping, even splattering the paint from sticks dipped into cans of car paint. What are the feelings expressed through Pollock's use of line?

Another way of looking at line in painting is in terms of direction and placement. In *Five Hot Dogs* the sandwiches are placed in a diagonal row, evenly spaced and symmetrical, suggesting products on an assembly line. What is Thiebaud saying about American culture through his painting of its favorite fast food?

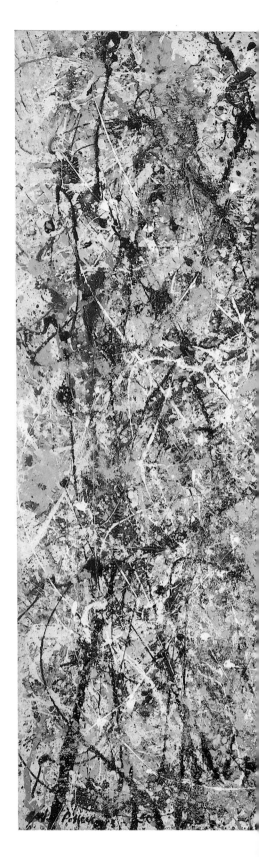

FIG. 5. Jackson Pollock, *Number 1, 1950* (also known as *Lavender Mist*), oil, enamel, aluminum on canvas, 87″ × 118″.
National Gallery of Art, Washington, D.C. (Ailsa Mellon Bruce Fund).

SHAPE AND FORM

Shape and *form* refer to the appearance of a particular area in a painting, such as a circle or a square or a triangle. Often these two words are used interchangeably. Artists use shapes and forms, as well as lines, to control the direction of our eye movements around the canvas. Shapes and forms are geometric, organic, or biomorphic.

Geometric forms are triangles, cones, circles, rectangles, and squares—shapes we have been looking at and identifying all our lives. They can be dense, open, active, soft, static, or closed, or combinations of these shapes. For example, a triangle can be an abstract shape—flat, hard-edged, and mechanical. But the angle of an arm and elbow of a figure in a painting can also be triangular, implying tension or motion.

Organic shapes are freer and less defined than geometric ones. These shapes often remind us of animal, human, or natural forms, such as a shell or a cloud. Biomorphic shapes are drawn from living organisms—an amoeba, for example. Consider the shapes in *Blam* (FIG. 6). The circular nose of the plane with the red half-moon and the oval shape of the fuselage with its curvy blue and white lines are flat and simplified, but volume is implied. Volume is the three-dimensional quality of these objects on the picture plane. The picture plane is the front surface of the canvas, the imaginary boundary between you and the painting. Here the shapes, as well as the lines, contribute to the explosive sense of movement.

In this painting, entitled *The Voyage* (FIG. 7), by Robert Motherwell, notice the geometric and organic shapes. A black heartlike form hovers over an ocher rectangle. A star braces columns of black and orange. The shapes appear flat but weightless, almost as if they were suspended in liquid. *Floating*, *nocturnal*, *somber*, *moonlike*, *stately*, and *majestic* are some sensory words that come to mind. The shapes in Motherwell's painting shape your response to the artwork. They look strong—even serious. The voyage, indicated by the title, symbolizes a meaningful passage, not a pleasure cruise. Even as a

FIG. 6. Roy Lichtenstein, *Blam*, DETAIL, 1962, oil on canvas, 68" × 80".
Yale University Art Gallery, New Haven, Collection of Richard Brown Baker.

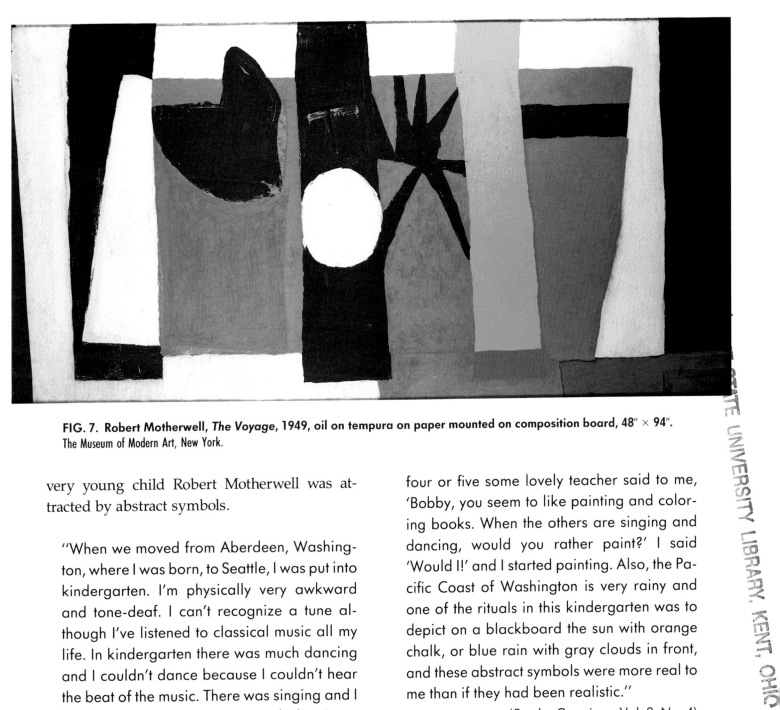

FIG. 7. Robert Motherwell, *The Voyage*, 1949, oil on tempura on paper mounted on composition board, 48" × 94".
The Museum of Modern Art, New York.

very young child Robert Motherwell was attracted by abstract symbols.

"When we moved from Aberdeen, Washington, where I was born, to Seattle, I was put into kindergarten. I'm physically very awkward and tone-deaf. I can't recognize a tune although I've listened to classical music all my life. In kindergarten there was much dancing and I couldn't dance because I couldn't hear the beat of the music. There was singing and I couldn't do the singing either, and when I was four or five some lovely teacher said to me, 'Bobby, you seem to like painting and coloring books. When the others are singing and dancing, would you rather paint?' I said 'Would I!' and I started painting. Also, the Pacific Coast of Washington is very rainy and one of the rituals in this kindergarten was to depict on a blackboard the sun with orange chalk, or blue rain with gray clouds in front, and these abstract symbols were more real to me than if they had been realistic."

(*Border Crossings*, Vol. 8, No. 4)

Shapes in Willem de Kooning's painting of *Woman on a Bicycle* (FIG. 9) are incorporated into the luxuriant surface of the canvas. It is hard to tell where the woman ends and the bicycle begins. De Kooning distorts and enlarges the shapes of the eyes, mouth, and breasts of this ferocious, grinning figure, producing a dramatic effect. *Brazen, florid, omnivorous, salacious,* or *menacing* are some words that describe the fleshy forms. The loose solid shapes suggest bicycle wheels or the woman's arm; the green rectangular shape might be a patch of grass. We can imagine the artist slashing layers of paint in dynamic gestures across the canvas.

The shapes in *Five Hot Dogs* (FIG. 8), the hot dogs, are the area of the painting called positive space. The empty space around the hot dogs is termed negative space. In *Woman on a Bicycle* the negative and positive shapes dissolve into each other. Figure/ground is another way of referring to positive/negative space.

Although the hot dogs are basically the same shape, you can tell them apart. Why do you think the artist made each one different?

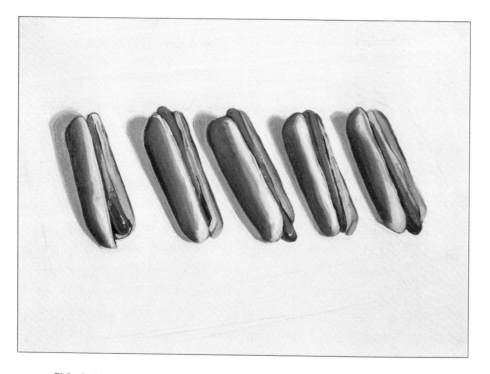

FIG. 8. Wayne Thiebaud, *Five Hot Dogs*, 1961, oil on canvas, 18″ × 24″.
Collection of John Bransten, San Francisco.

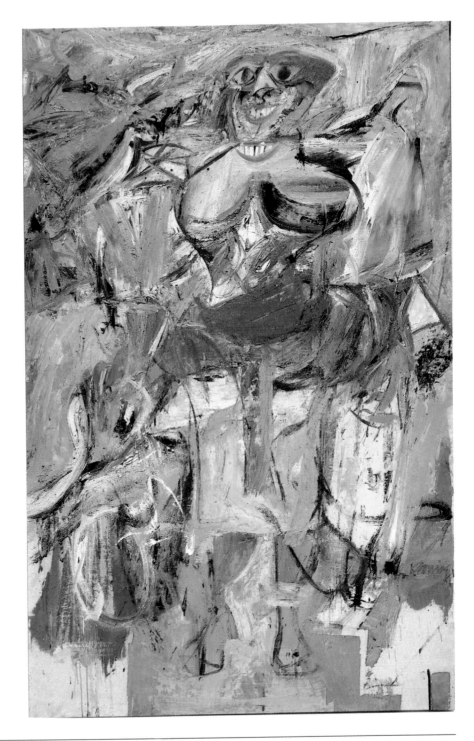

FIG. 9. Willem de Kooning,
Woman on a Bicycle, 1952–53,
oil on canvas, 76½″ × 49″.
Whitney Museum, New York.

THE LANGUAGE OF ART

27

TEXTURE

Texture refers to the surface of the canvas, especially the way it stimulates our sense of touch. Look at the actual surface of a painting. Is it flat or bumpy? Is the paint thick or thin? Or the artist may be concerned with creating the illusion of texture, such as the velvety softness of rose petals, the lustrous quality of lipstick, or the translucence of glass. Actual material attached to the canvas, such as wood, paper, string, or actual objects, creates a third kind of texture in painting.

In *House of Fire* (FIG. 10), by James Rosenquist, the lipsticks look so slick and creamy that you almost could reach out and sample one on the back of your hand. You could eat a banana right out of the paper bag. These incongruously grouped objects—lipsticks, the ladle filled with molten metal, and the upside-down grocery bag—spill out of the picture plane, reminding us of the barrage of images that confront us daily. The lipsticks are poised threateningly like missiles ready to be fired. *Hard, bright, glossy, sharp-edged,* and *metallic* are some sensory words that come to mind.

Here the texture refers to the way the actual objects might look and feel, but it is exaggerated, more real than a photograph. In this painting no brushstrokes are visible, and as in

James Rosenquist at work on a painting in his studio.
(© 1986 Bob Adelman)

THE PAINTER'S EYE

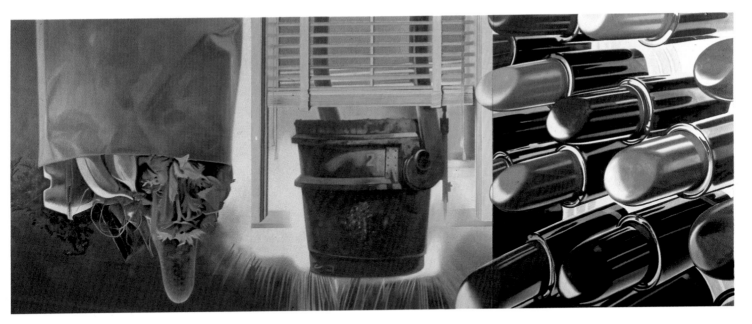

FIG. 10. James Rosenquist, *House of Fire*, 1981, oil on canvas, 78″ × 198″.
Metropolitan Museum of Art, New York (purchase George A. and Arthur Hoppock Hearn Funds and Lila Acheson Wallace gift).

Lichtenstein's *Blam,* the smooth surface reminds us of a commercially reproduced image, in this case a billboard.

James Rosenquist's sense of gargantuan scale and wide-angle vision were derived from outdoor billboards he once painted as well as from the midwestern landscape he viewed as a child.

"I was born in the Midwest in the thirties. My parents were fliers. While she was pregnant, my mother worked as a secretary for a propeller company. In the next room they carved propellers out of wood. So you might say I was propelled into space.

"As a child I lived on a farm in North Dakota. I was alone a lot, and since we were in the middle of nowhere, I had to invent my own entertainment. There were no toys. I remember taking a tree limb and carving a scale model out of it. That's a very different kind of experience than a child might have today, going into a dime store and buying a model plane out of plastic. The landscape was so flat, you could see for miles. Once I looked out the window and saw a three-story-high white stallion go by. It was a mirage. Actually it was the neighbor's plow horse in the distance. But things happened there at a different speed with a different sense of space. The landscape felt surrealistic."

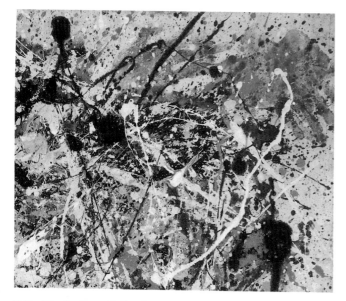

FIG. 11. Jackson Pollock, *Number 1, 1950*
(also known as *Lavender Mist*), DETAIL,
oil, enamel, aluminum on canvas, 87″ × 118″.
National Gallery of Art, Washington, D.C. (Ailsa Mellon Bruce Fund).

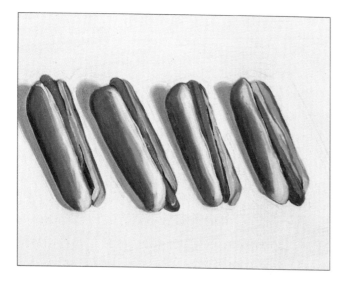

FIG. 12. Wayne Thiebaud, *Five Hot Dogs*, DETAIL,
1961, oil on canvas, 18″ × 24″.
Collection of John Bransten, San Francisco.

The texture of *Number 1/Lavender Mist* (FIG. 11 detail) beckons to be touched because the paint is so gloppy and gritty. In this detail the intricate web of lines are so shiny that they still look wet. Sensing whether the surface is rough or smooth, grainy or gossamer contributes to our feelings about the painting.

Actual objects fastened on the canvas, as in Robert Rauschenberg's painting of *Bed* (FIG. 13), demonstrate a third kind of texture. He calls this a "combine painting" because he has combined real materials, pieces of an old quilt and sheets from his bed, with paint on the canvas. The quilt, sheets, and pillow of *Bed* are somewhat flattened; the bed is smaller than a real bed. Mounted on the wall, these objects become the surface on which an artist paints, instead of a canvas. Thickly applied streaks of paint on the sheet add more texture to the painting. Here you see the marks of the artist's brush and paint that seems to be squeezed directly from the tube. If the artist had painted the quilt, instead of using a real one, would your response to the painting be different?

Thiebaud offers *Five Hot Dogs* (FIG. 12) on an empty surface, rather than on a paper plate or in a concession stand. Ridges of white paint circle the objects, highlighting them. The artist's brushwork is deliberately rich and juicy, inviting us to pick up a hot dog and take a bite. Wayne Thiebaud, Roy Lichtenstein, and James Rosenquist each present the symbols of our consumer culture, using distinctive visual techniques.

THE PAINTER'S EYE

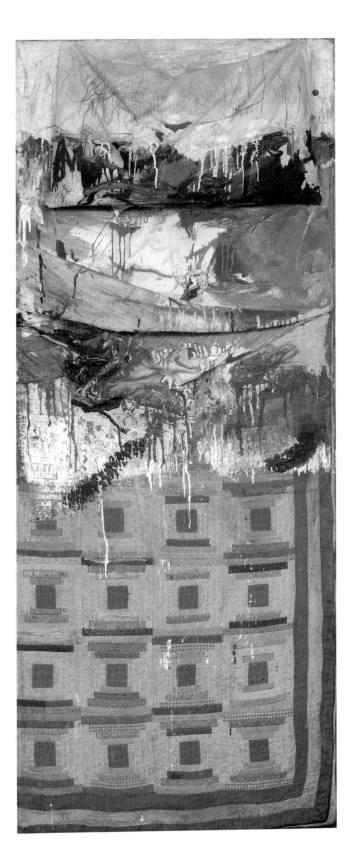

FIG. 13. Robert Rauschenberg, *Bed*, 1955, combine painting, 74″ × 71″.
The Museum of Modern Art, New York (gift of Leo Castelli).

COLOR

Color is probably the most obvious element of art. It influences how we feel about an artwork and is often what we remember most. We all identify certain colors with emotions: "I'm in a blue mood"; "He has a yellow streak." While red represents love or anger, certain objects are associated with the color red—an apple or a fire truck—as well as holidays—Christmas or Valentine's Day. Think green. You might picture the squash green grass of winter or a spruce against a blanket of snow. Colors can also recall a certain smell or taste—the golden citron of a lemon or the sugary pink of cotton candy. Some color references are common, such as sun/yellow, while others are personal. For example, a pale sulfur yellow brings to mind the early-morning sky in Los Angeles.

Some of the properties of color are hue, intensity, and value. Hue is pure color: red, orange, yellow, green, blue, indigo, and violet. A painting filled with intense red, orange, or yellow hues can be exciting or even violent, as in Lichtenstein's *Blam*. The duller the color, the softer it seems, as in the blue-gray of dusk or the pale blue of a misty day. Artists use intensity of color to convey mood. Value refers to light or dark aspects of color. The lighter the color, the closer it is to white, the darker the color, the closer to black. Dark and light colors and how they relate

to bright or dull colors is one way to define contrast in art. Colors that are opposites, such as red and green, purple and yellow, or orange and blue, are called complementary colors. Placed together on a canvas, they almost seem to vibrate. Artists take advantage of all the technical ways to use color. You will find a more detailed explanation in the glossary.

In *Bedroom Painting #7* (FIG. 14) by Tom Wesselmann, we see the effect of intensity in color. A large flesh-colored foot is bordered by items that might be found in a woman's bedroom: an orange, daffodils, and a fake leopard-skin cover. Although the foot with its cherry red toenails is the main attraction, the other objects are equally as bright and intense. They draw our eye around the canvas and balance the composition. The blue wall and deep brown tabletop provide a contrasting background, which pushes the foot forward out of the picture plane into our space. The orange shades of the fruit and flowers add a luscious overtone to the rosy flesh. The elements are flat, yet there is implied volume through the shine on the red polish, the shading between the toes. Even though this is a stylized depersonalized image, we sense that it might exist in the real world. The effect is both witty and erotic. It's as if a camera had zoomed in on an intimate detail. Sensory words that come to mind are *garish, stilted, flat, cool, sensuous, intimate,* and *cropped.*

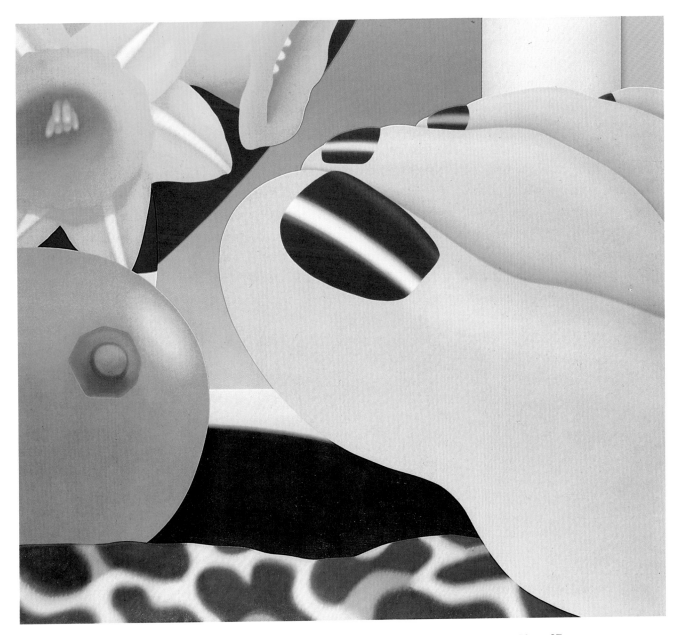

FIG. 14. Tom Wesselmann, *Bedroom Painting # 7*, 1967–69, oil on canvas, 78″ × 87″. Philadelphia Museum of Art.

About his childhood, Wesselmann said,

"I had no contact with or awareness of art. I thought all art was Norman Rockwell magazine covers. My first real encounters with art occurred in galleries and museums when I came to New York in my mid-twenties to go to art school (to become a cartoonist). Once, in the midst of painting a landscape outdoors, I, totally naive, couldn't understand the point the teacher was trying to make. 'Try it this way,' he said in exasperation, taking my brush and making some strokes on my canvas. I realized he was painting what he was seeing and I had been painting a design I had in my head. From that moment on I became an artist."

Creating an entirely different color effect, through contrasts in value and intensity, Mark Rothko's *Number 61* (*Brown, Blue, Brown on Blue*) (FIG. 15) is an abstract image in deep blues, browns, and purple. By applying thin washes of paint, one over another, allowing some of the colors to seep through, Rothko creates the subtle effect of a hidden light source. His colors are translucent and misty; the effect is mysterious and atmospheric. The electric blue in the center is more intense than the other colors. If the two heavier masses of brown above and below did not hold the blue in place, it would burst out of the canvas. The dark (brown) and bright (blue) colors provide an ever-shifting relationship between the shapes.

Mark Rothko in his studio.
(© Hans Namuth, 1966)

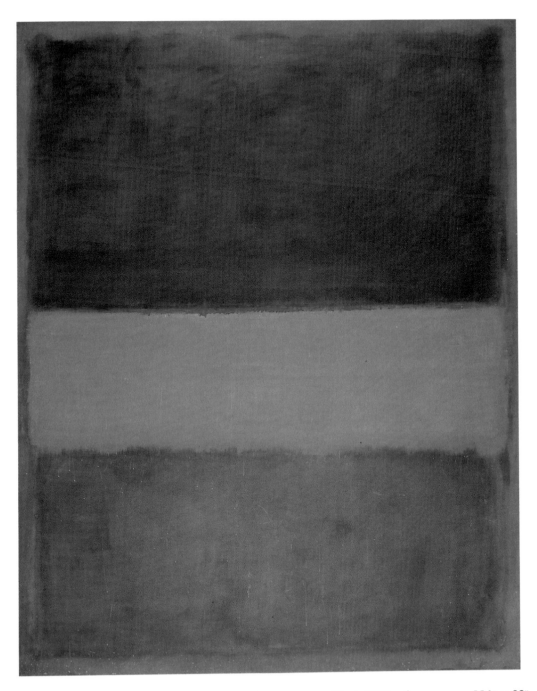

FIG. 15. Mark Rothko, *Number 61 (Brown, Blue, Brown on Blue*), 1953, oil on canvas, 116″ × 92″.
Museum of Contemporary Art, Los Angeles, Collection of Count Panza di Biumo.

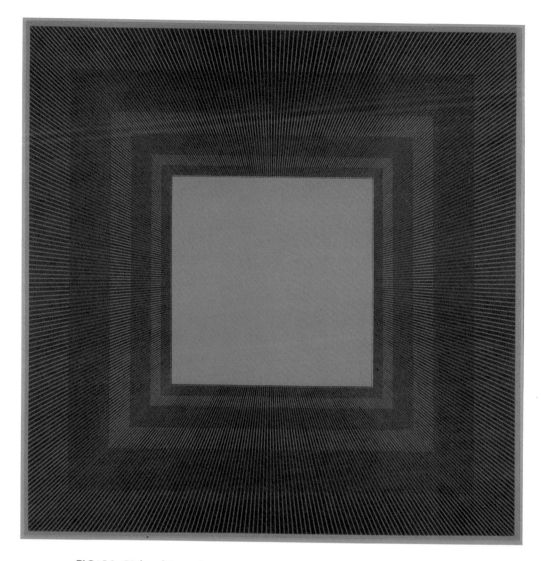

FIG. 16. Richard Anuszkiewicz, *Sol II*, 1965, acrylic on canvas, 84″ × 84″.
Milwaukee Art Center (gift of the Friends of Art).

The effect of complementary color is the most striking aspect of *Sol II* (FIG. 16) by Richard Anuszkiewicz. Here a large green square is placed in the center of a field of red. Three orange bands of increasing width frame the square. Thin white lines radiate from the square, turning yellow where they intersect the orange bands. The interaction of complementary colors,

red and green, produces an optical illusion, causing the green square to advance and retreat. The effect is a pulsating visual rhythm, throbbing like a heartbeat, as hypnotic as a mantra. The blue and green border confines the powerful color effect within the margins of the picture plane. Some sensory words that come to mind are *dazzle, trick, assault, disturb, push, pull.* In *Sol II* Anuszkiewicz uses simple geometric shapes in a precise mathematical arrangement. The paint surface is smooth, anonymous, with no brushmarks. These aspects of his painting, as well as his use of a scientific approach to color, have identified him as an op artist.

As an art student at Yale, Anuszkiewicz became involved in color perception.

"An interest in spatial ambiguity grew out of a paper I wrote about the creation of space through drawing. I particularly enjoyed playing with positive and negative space, making something that appears to be behind move forward and then back. In this way figure [the green square in *Sol II*] and the ground [the red background] interchange. I also became fascinated by the fluorescent effect of putting opposite colors, such as blues and oranges, together. My hope was to find a personal direction and to let the seeds grow into a beautiful garden of my own."

The artist remembers always drawing.

"My father helped me and became my first teacher. Because he worked in a factory that manufactured roofing paper, he brought home lots of scrap paper and sample tablets. So I had all sorts of materials available. He gave me a little exercise, involving a series of dots which I connected. I would make soldiers and other figures with the dots. Drawing things was the first way I learned to communicate."

Thiebaud's color in *Five Hot Dogs* is carefully chosen as well. The stark white background presents a perfect stage for the stars of this painting. The contrast between the background and the brightly painted hot dogs makes them stand out. The hot dogs are painted in earthy tones of red, brown, and yellow. Why does Thiebaud choose such sensuous colors for the common hot dog?

To concentrate solely on the bits and pieces of a painting is to miss the meaning of the whole. What provokes our interest in *Five Hot Dogs* and the other paintings in this chapter comes from the artists' skill at putting the elements together. Through the elements of art—line, shape, texture, and color—we have come a little closer to seeing how an artist expresses his or her ideas and feelings in a painting, how artists "say" what they mean.

3

WHAT DOES IT ALL MEAN ANYHOW?

When we pull a painting apart and put it back together again, we raise questions. We ask why. Why does Jackson Pollock build up the surface of the canvas with his thick web of lines? Why does Mark Rothko stain paint into the canvas so that it almost appears to be dyed? Why does Robert Rauschenberg use part of an old quilt for his canvas?

By looking at the parts, we discover something about the whole. Every painting contains a series of choices made by the artist. The subject, the style, the size, the material, the way the elements are used are only some of the decisions the artist makes. So as we look at the elements, the parts of a painting, we are considering these choices—for example, an abstract rather than a realistic shape; mysterious blue, not Day-Glo orange; an old quilt, not a new canvas.

Probably most paintings are a mixture of deliberate or intuitive artistic decisions and the influences of the community and culture in which the artist lives. But even if an artist exercised conscious control over every part of a painting and was able to put all his decisions into words, even if he stood right in front of us and explained the painting, he could tell us what he intended to do, but not what the painting does.

Sometimes the painting doesn't communicate the artist's intention. Sometimes it succeeds in ways he or she didn't expect or imagine. And then, once it is on a wall in a museum, the painting takes on its own life because we each bring our own ideas and personal associations to the work. Part of what makes art interesting is that there is room for a variety of individual responses from the viewer. In asking why, asking what was the intention behind the artist's choices, we often find answers to other intriguing questions:

What does the painting mean?

What does it make you think of?

What is the feeling expressed in the painting?

How do you feel about it?

Let's look again at the familiar *Five Hot Dogs* (FIG. 17). What is the meaning of this painting? Why does Thiebaud paint such a beautiful picture of ordinary hot dogs?

The hot dogs, lined up in a neat, uniform row, look almost as if they have just come off a production line. Yet the shape of each one is a little different. The paint texture makes our mouth water. The hot dogs are good enough to eat.

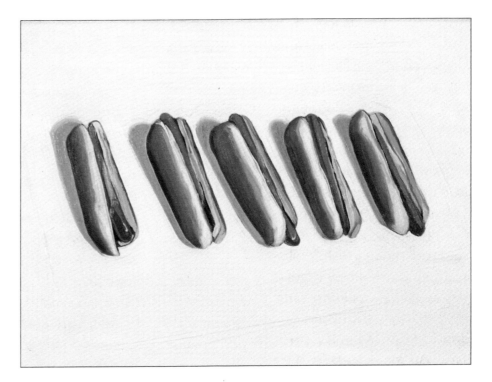

FIG. 17. Wayne Thiebaud, *Five Hot Dogs*, 1961, oil on canvas, 18″ × 24″. Collection of John Bransten, San Francisco.

Thiebaud is treating the lowly hot dog as a serious subject for art. Yet humor is implied by its very seriousness. The traditional notion of still life painting was the elegant presentation of a bowl of fruit, a vase of flowers, or perhaps a more humble jug of wine and loaf of bread on the table of the artist. If bread and wine formerly were ordinary fare, in this time and culture it is the hot dog.

Word association is one way to collect your impressions of a painting, by finding out "what it reminds you of." A short list for hot dogs might include *picnic, baseball, beach, campfire, circus, cheap, easy-to-eat, easy-to-cook, American.*

So hot dogs are cheap and mass-produced; you can afford one even when you're broke. But you usually eat them when you're having a good time. They are an American food, American as baseball. And here are five of them, too many for one person to eat, enough to share, enough for everyone. The hot dog becomes the metaphor for the energetic spirit of America. Thiebaud is celebrating America's taste. But is he really that serious about these hot dogs? Perhaps he is poking fun at them, at us, too, by enshrining an ordinary object of our culture, taste at the most popular "gut" level.

Wayne Thiebaud, who lives and works in California, always drew and found images of popular culture interesting.

"I started drawing cartoons because I loved them so much. It was a way of expressing myself. I expect my teachers noticed I spent more time doing that than schoolwork. When I broke my back (at sixteen), I was bedridden, so I had no distractions. I spent my time drawing for many hours every day. I suddenly realized something. . . . The more I drew, the more I improved. Before that, I always thought drawing was a talent. Cartooning is a great graphic art form and hasn't been given its due, although now more books are being written about it. I continue to have an interest in caricature and its effect on stylization—for instance, the many ways color, light, space, and shapes can be caricatured. Styles in painting are based upon distorting various elements in order to move them away from the ordinary to the extraordinary."

In *Bed* (FIG. 18) by Robert Rauschenberg we were struck by the textures in the painting: the old frayed handmade quilt with its colorful abstract design; the wide paint strokes on the sheets and pillow; the squishy, loose quality of the brushwork. We wondered why the artist used an actual quilt and sheets instead of painting a representation of them.

Well, why not? If an artist experiments with materials, why not use whatever is at hand to express his or her ideas? Viewed in this way, the common objects in our everyday life, from soup cans to targets to hot dogs, or found objects,

from a cast-off tire to an old quilt, become possible material for making art as well as subjects of art.

Another answer might be that the quilt personalizes the subject: a bed. The quilt is old, not new; the texture, soft and rubbed. Certainly we feel someone slept under that quilt, lived in that bed. He ate there. He dreamed there. He may have even watched television in that messy bed. The artist suggests the history of the bed and the presence of a person by painting the traces the person left on the bed.

We have said that the response to a painting is individual. In fact, one critic's opinion is that the red dripping paint and other splashes of color indicate that a murder has taken place, that the bed was the scene of a crime! That didn't occur to us when we looked at *Bed*. Still, the other viewer makes a good case. Think about the contrast between the cozy normality of the old quilt and the wide slashes of paint that might bear testimony to a grisly homicide. In trying to answer why the artist incorporated an actual quilt or what the feeling expressed by the artist's use of textures and colors is, we arrive at two possible answers to "What does it all mean anyhow?" Both agree that the use of a quilt and thick paint implies a biography, but the conclusion is not the same.

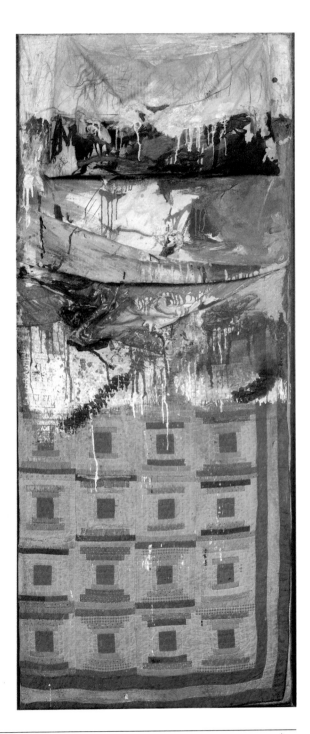

FIG. 18. Robert Rauschenberg, *Bed*, 1955, combine painting, 74" × 71". The Museum of Modern Art, New York (gift of Leo Castelli).

In *Number 1/Lavender Mist* (FIG. 19) line is used to directly and immediately express the artist's emotions on the canvas. The painting takes up almost a whole wall of a museum gallery. You can trace the lines of paint in the air, standing in front of the canvas like a conductor of an invisible orchestra, feeling in your arm the gestures Pollock might have made. Sweeping, delicate, quick, wide, free, staccato—Pollock orchestrated a symphony of line and color.

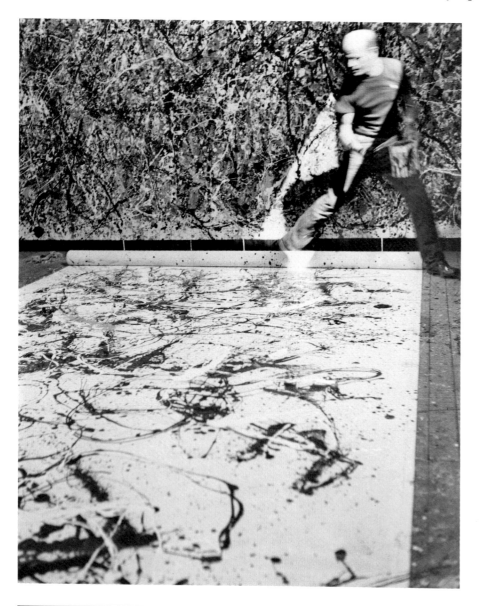

Jackson Pollock in motion, at work on a painting in his studio. A second painting is propped against the wall behind him.
(© Hans Namuth, 1950)

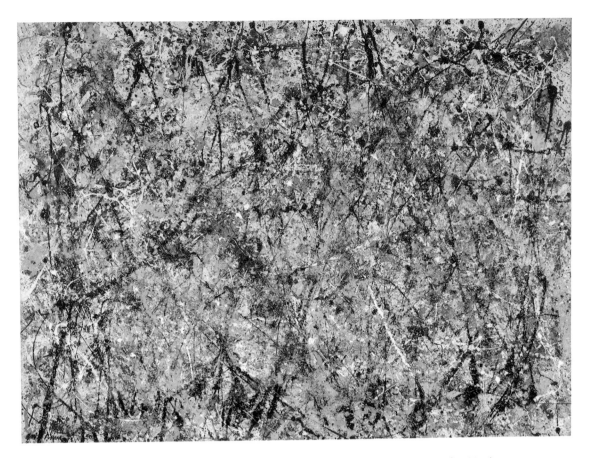

FIG. 19. Jackson Pollock, *Number 1, 1950* (also known as *Lavender Mist*), oil, enamel, aluminum on canvas, 87″ × 118″. National Gallery of Art, Washington, D.C. (Ailsa Mellon Bruce Fund).

Jackson Pollock was perhaps the best-known postwar American artist, but also the most controversial. He tried to express his emotions spontaneously without using a preconceived, recognizable image. He said,

"When I am in my painting, I'm not aware of what I'm doing. It is only after a sort of 'get acquainted' period that I see what I have been about. I have no fears about making changes, destroying the image, etc., because the painting has a life of its own. I try to let it come through. It is only when I lose contact with the painting that the result is a mess. Otherwise there is pure harmony, an easy give and take, and the painting comes out well."

(from "My Painting," *Possibilities I*, Winter, 1947–48)

The texture is dense, built up with many layers of paint—lines that track and cover, forming an interlaced barrier. What lies beneath? We can only wonder. The painting keeps the artist's secrets. Perhaps we have secrets of our own, hidden layers. And so we see ourselves in the painting, feel the tension between the public, extravagant, virtuoso display and the private layers, painted over, hidden underneath.

Here is how a poet responded to a similar "drip" painting by Pollock:

Number 1 by Jackson Pollock (1948)

No name but a number.
Trickles and valleys of paint
Devise this maze
Into a game of Monopoly
Without any bank. Into
A linoleum on the floor
In a dream. Into
Murals inside of the mind.
No similes here. Nothing
But paint. Such purity
Taxes the poem that speaks
Still of something in a place
Or at a time.
How to realize his question
Let alone his answer?

Nancy Sullivan

Number 61 (FIG. 20) is just as abstract, but it inspires a different reaction from *Number 1/Lavender Mist*. Here the shapes, colors, and textures envelop us, pull us into another world, a world of mystery and beauty. With subtle variations in the blues and browns, floating shapes, and a soft veillike texture of colors that seem to slide over one another, Rothko's large canvas creates an aura of depth and grandeur. Some word associations we might make are *twilight, sky, magic, soft-edged, languid, nocturnal, deep, tranquil,* and *serene.*

We have suggested that another way to understand a painting is to explore the physical sensation it evokes. You can feel the energy in Pollock's painting *Number 1* by tracing its lines in the air. The painting is vigorous and energetic. Rothko's painting is more mystical. It seems like a doorway to a different world, another time and space. Ask yourself some questions about how it would feel to step through that doorway. If you could walk into *Number 61*, what would you see? How would you move? Would you dance or tiptoe carefully? How would the atmosphere of the painting feel against your skin? Like velvet or perhaps like water? Warm and soft or cool or liquid?

You might want to write a poem about this painting or choose a piece of music to express its mood.

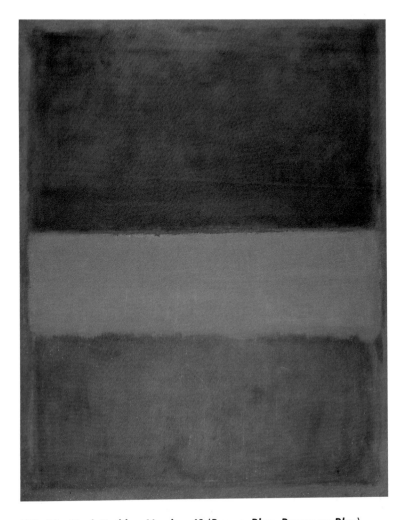

FIG. 20. Mark Rothko, *Number 61 (Brown, Blue, Brown on Blue)*, 1953, oil on canvas, 116″ × 92″.
Museum of Contemporary Art, Los Angeles, Collection of Count Panza di Biumo.

As we saw with *Bed*, some of what a painting means depends on who is looking at it. These are explorations of the feeling and meaning of a painting by responding to it in a personal way. There are no right and wrong answers as long as you can "prove" your point of view by referring to the way the artist has used the elements of color, shape, line, and texture.

PUTTING IT ALL TOGETHER— ELLSWORTH KELLY

L et's start with the question, What's it all about? Imagine standing before *Spectrum II* (FIG. 21) by Ellsworth Kelly. It's an oil on canvas six and a half feet high by twenty-three feet wide with thirteen vertical panels, each a different hue, each of equal size. To get an idea

of the painting's size, you might want to measure it out on a wall or on the floor. You can do it with string or tape. Unless you're in a train station or warehouse, it might be hard to find a space big enough. The painting fills an entire wall in a museum.

We can begin with the elements. The first thing you notice about this painting is color. Let your eyes move from color to color. How does the violet relate to the blue on the left? The violet becomes stronger next to the red. Kelly is interested in how colors interact with one another. If you squeeze your eyes tightly and squint, you will see that the painting becomes a band of flowing color. The blue and the red dissolve into each other. When you see this painting in the museum rather than in a reproduction, the edges between each color glow.

FIG. 21. Ellsworth Kelly, *Spectrum II (Thirteen Panels)*, 1966–67, oil on canvas, 80″ × 273″. St. Louis Art Museum.

The colors have been carefully chosen. At first glance the red panel appears to be stronger, then other colors begin to stand out, so that each panel, as you focus on the yellow, green, blue, violet, red, to yellow, in turn recedes or vibrates off the wall. Yet each has equal power, thus emphasizing the overall flat composition. To achieve this effect, Kelly experimented with primary colors (red, yellow, and blue) and secondary colors (orange, green, and violet) as well as with the size and shape of the panels. Kelly said:

"One critic dismissed the big spectrum painting by saying, 'It's just a bunch of colored rectangles. So what?' In fact, that painting was a difficult one for me. I spent all summer working on it. Each color has a thousand variations, and I needed to find the ones that had the right value and intensity. Another problem is that paint color changes when it dries, so I had to work from a memory of what color can do. I wanted the viewer's eye to move from one color to another so evenly that you don't notice any one color. Nothing stands out."

At first Spectrum II seems to be about color, but the painting is also about shape. The painting is a long rectangle, made up of thirteen vertical panels. Even though the panels are ver-tical, the interaction of the colors forces our eye to move horizontally across the picture plane. Many viewers try to relate an abstract painting to an object, but Kelly didn't intend us to think of Spectrum II as a rainbow or a color chart.

The texture of this painting is flat. Kelly used many layers of paint, but there are no brushstrokes visible because he doesn't want to call attention to the surface. The canvas itself is the object. Color and shape are the subject.

At the edge where two panels meet, there is a line. Although this is not a painted line, each implied line, as one color touches the next, enhances the linear effect of the painting. Referring to the separations in Spectrum II, Kelly said,

"They make a line. That's what I wanted. Each color is a unity by itself. I wasn't depicting colors. But I was presenting color, creating literal space."

By literal space, Kelly means that the painting exists for itself like any other object. It is not a representation of anything else. Kelly added:

"A painting with drawn lines, marks, or brushwork within a four-sided frame is usually a depiction of something. But if you have a red panel next to a blue panel, they don't de-

pict anything. They are panels of color. I want my paintings to be on a one-to-one basis with everything else. For example, that's a table, this is a rug, that's a glass, this is a canvas. For this reason I eliminated drawn lines and marks; the brushmarks almost disappear.

"In a painting that is a depiction, you investigate only what is within the four sides of the frame. Your world is there. But in the real world when you look at a shape that exists, for example, a lampshade in a room, the interest lies in its edges, how it relates to the windows, the wall, and the furniture. Then you might think of my shaped canvases. I want that kind of bounce, that interplay between other elements. Very early I wanted to search outside my own personality, to present something that had to do with investigating vision, a different way of seeing."

What is the feeling expressed in *Spectrum II*? *Spectrum II* is like a bright banner unfurled against a white sky. The colors speak of moods—a precise arrangement of sounds. Hot notes followed by cool notes—bands of color unfolding like a melody.

Ellsworth Kelly at work in his studio.
(© Gianfranco Gorgoni)

Spectrum II
(for Ellsworth Kelly)

Columns vibrate off the wall,
each panel, a window to the next.
A ray of sunlight slips through. Now
the scent of freshly mowed grass,
an indigo sea. The sky at noon
fades into amethystine dusk.
Fields of wheat ripple on the sun-baked earth.

Painted doorways in a sunny place,
chimneys, pipes, windows and city walls
reach towards the sky.
Colors, separate and distinct, yet
shimmering, slide together. We move
through corridors of radiant light.

Jan Greenberg

CONVERSATION WITH ELLSWORTH KELLY

Q. "Where did you get the idea for *Yellow with Red Triangle?*" (FIG. 22)

A. "The shape of the two panels was abstracted from something I observed in the architecture of a house near my studio. The sloping roof of a house became a yellow rectangle placed on a diagonal; the dormer window on this roof seen from the side became the red triangle. I kept looking, and then I began making drawings. I always do a lot of drawings from various angles or viewpoints. I liked the triangular form with the diagonal. A series of paintings developed from the drawings.

"I want to use the world rather than my own invention. Everywhere I look, I see relationships—forms and colors. And I break them down to the bare essential of forms."

Q. "Was there a particular incident in your childhood that influenced your perceptions?"

A. "I remember even when I was quite young letting loose visually and playing with color. The idea is to stop thinking and investigate what you see. Look at things sideways or upside down. If you start concentrating on vision, you have to forget everything else. It's kind of scary to let go. The first time I experienced this I was about thirteen. I went out to my cousin's farm in Ohio and became ill from eating green corn. I was in bed for a few days with a fever. At some point I got up, sat down on a chair, and fainted. My head dropped forward. I don't know how long I was there before my eyes opened. What I saw beneath my legs was a different world. *Where am I?* I thought. I couldn't raise my head until I found out. It's a question of letting your mind go to sleep and just using your eyes."

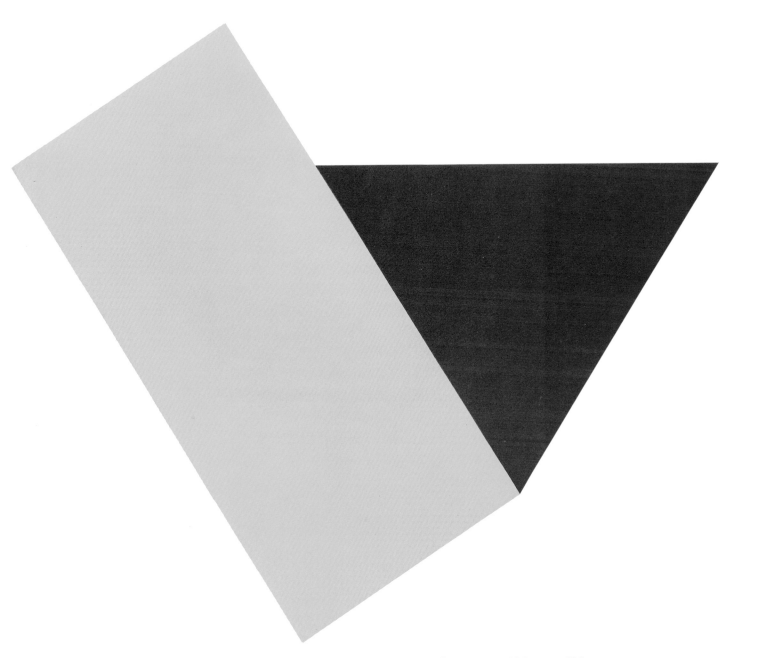

FIG. 22. Ellsworth Kelly, *Yellow with Red Triangle*, 1973, oil on canvas, 305 cm. × 306 cm.
Corcoran Gallery of Art, Washington, D.C.

PUTTING IT ALL TOGETHER—ELLSWORTH KELLY

5

VISUAL EFFECTS: ONE AT A TIME

By manipulating the elements of art, a painter solves visual problems. Either through training or intuition, artists are aware of the way the viewer responds to certain visual effects. Some of these visual effects are: balance, rhythm, variety, emphasis, unity, spatial order. Think of them as the tools or devices that the artist uses to compose a picture and to express emotions or ideas. If we know something about the way the parts or elements of a painting are arranged, we can better understand its artistic meaning. The artist's goal is to bring the elements together into a unified whole. If a painting isn't unified, it doesn't work. This chapter is about what makes a painting work.

A BALANCING ACT

While gazing at the sky on a clear night, we are overwhelmed by the vast array of stars. But gradually our eyes begin to make order out of individual stars, to single out the brightest ones, to arrange groups of stars into clusters; in other words, we automatically seek to organize our field of vision. One of the ways we order our visual experience is through balance. Balance is the principle of art that refers to giving equal weight to the shapes, colors, lines, or textures in a painting. Without balance, the painting looks awkward to us.

FIG. 23. Frank Stella, *Fez I*, 1964, fluorescent alkyd on canvas, 77" × 77". Albright-Knox Art Gallery, Buffalo.

Fez I (FIG. 23) by Frank Stella represents formal balance. The line down the middle, dividing the canvas into two sections, is called the central axis. Formal balance is easy to spot because the areas on either side of the center are the same or similar. In *Fez I* the line is real. In most paintings it is an imaginary line that may be either horizontal or vertical. *Fez I* is balanced both ways.

What is the visual effect of *Fez I*? Glaring tentlike rainbow stripes repeat themselves in a taut geometric design. In spite of the gaudy colors, the diagonal lines create a formal or rigid effect. The green and yellow stripes produce an optical illusion. At first yellow comes forward and green recedes; then just the opposite occurs. Positive and negative space become interchangeable.

In *Blue Veil* (FIG. 24) by Morris Louis, a fan of color in cool blues, greens, and violets unfolds across the raw canvas. A contrasting band of yellow and orange peeks through the top edge. There are subtle variations in the shapes and colors, yet the format is similar on either side of the axis line. The colors seem overlaid, striated without apparent change in the surface texture. We are enfolded in a diaphanous curtain.

This poem captures the lyrical effect of *Blue Veil*:

To Morris Louis of the Blue Veil 1958–59

No longer tension, no dimension, only the
words without letters
floating in their washes, hiding Salome,
the figure behind our musings
trapped in her camouflaging dance.
The limit makes the shape
and we have none,
no bodies for the indistinct yearnings
ebbing into mists, desire and mist.
Imagine the sea without a surface,
the sky without a sun,
and no earth at all,
only the light
blending into pigments
and arching back again.

Anne Chernay

FIG. 24. Morris Louis, *Blue Veil*, 1958, 100½" × 149". Fogg Art Museum, Harvard University, Cambridge.

Informal balance, the arrangement of dissimilar forms, is achieved in Frank Stella's *Il Dimezzato* (FIG. 25), a flamboyant three-dimensional painting. This is a more daring, complicated balancing act than *Fez I* and depends on the interplay of various elements: hot and cool colors, large and small repeated shapes, and contrasting geometric and free-form patterns and textures. The large burgundy cross anchors the painting, gives it weight, balancing the lighter, more playful elements surrounding it. The shapes are frozen in motion. The striped cones and spheres of painted aluminum seem to pop open, out and off the wall. In this painted metal relief Stella has crossed the boundaries between painting and sculpture.

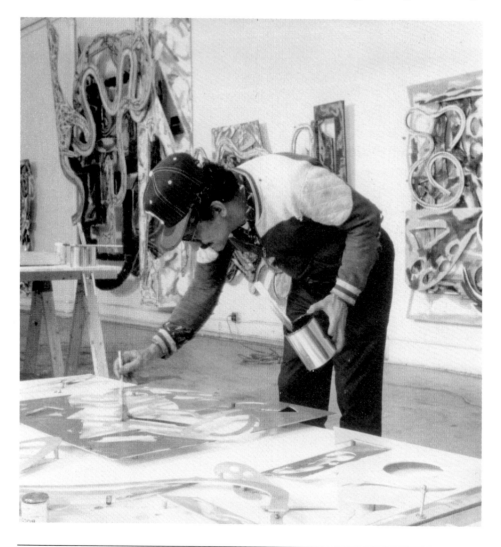

Frank Stella at work in his studio.
(© Marina Schinz)

THE PAINTER'S EYE

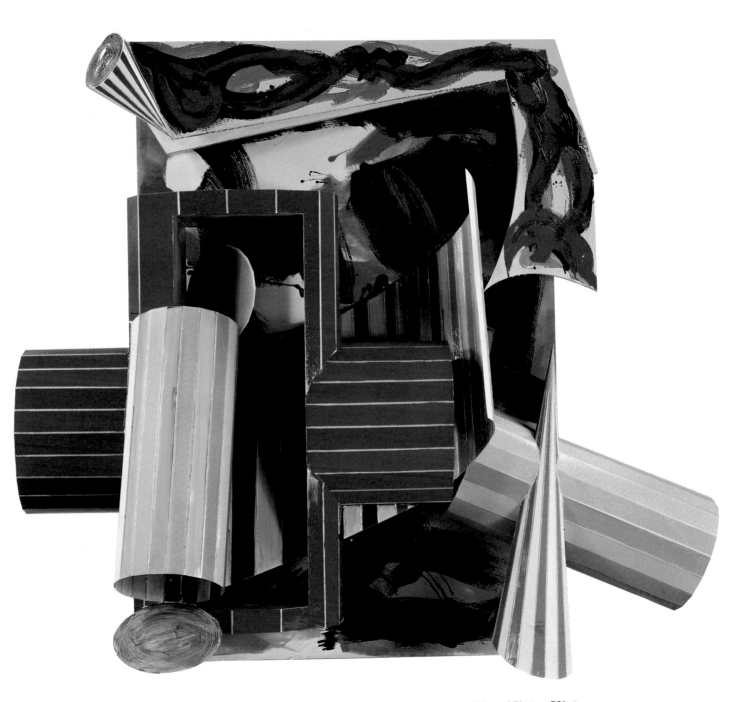

FIG. 25. Frank Stella, *Il Dimezzato*, 1987, painted aluminum, 88″ × 95¾″ × 53⅜″.
Greenberg Gallery, St. Louis.

VISUAL EFFECTS: ONE AT A TIME

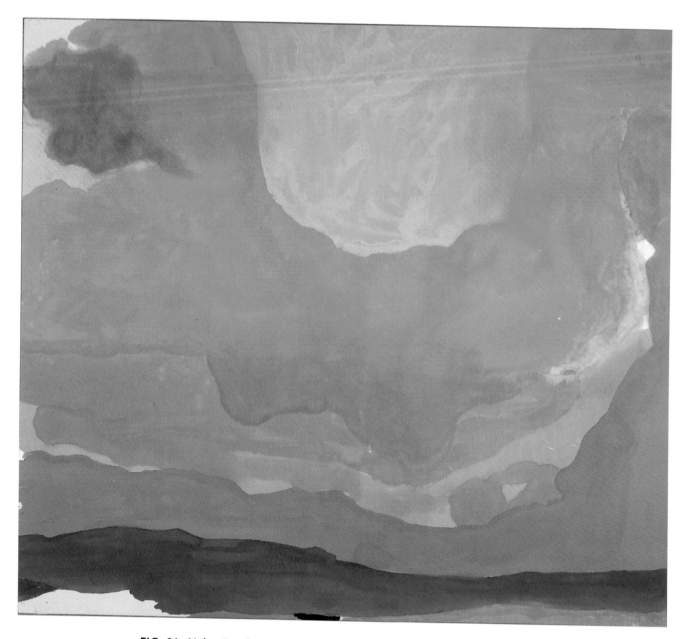

FIG. 26. Helen Frankenthaler, *Flood*, 1967, acrylic on canvas, 124″ × 140″.
Whitney Museum, New York.

REPEATING RHYTHMS

Visual rhythms form patterns everywhere we turn: ripples in a stream, grapes on the vine, ties on a railroad track, the landscape viewed from a plane above, a soccer game in progress. Picture the railroad ties, then the soccer players running up and down the field. Railroad ties form a regular rhythm with equal space in between. The soccer players move at a random rhythm, a pattern that repeats itself in no apparent order. In painting, rhythm expresses movement by repeating colors, shapes, lines, or textures.

In this large painting *Flood* (FIG. 26) by Helen Frankenthaler, sumptuous colors rise and swell in an expanding, rolling rhythm: rose, peach, mauve, burnt orange, pumpkin, sage, canary yellow, and wine-blue. The thin texture of paint stained into the canvas adds to the sensation of liquidity. Imagine entering the canvas and moving through this tidal wave of color. The painter's use of hot, swirling pink and orange with cooler blues and green takes us from an arid, open landscape to one that is moist and lush. Even though this painting is abstract, we think of clouds, sunrise-sunset, deserts, or sea.

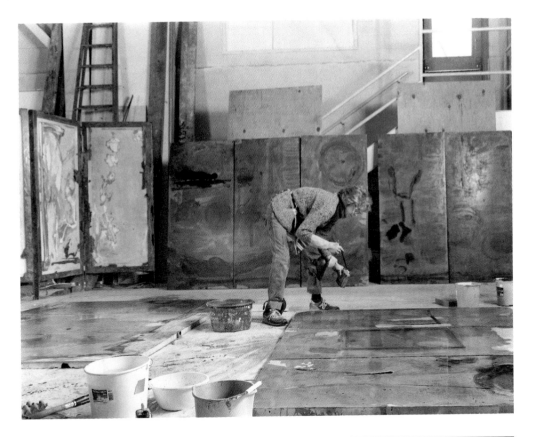

Helen Frankenthaler at work in her studio.
(© Hans Namuth, 1987)

Frankenthaler's paintings, often large-scale fields of color, emphasize color and shape on a flat surface and explore the relationship between art, self, and nature.

"My first awesome experience with the natu-

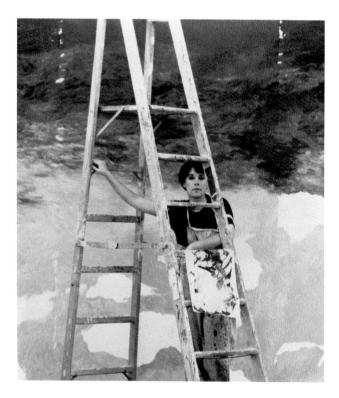

Jennifer Bartlett at work on one of her paintings.
(© Eric Boman)

ral world . . . was this: at an early age I would call my mother to the window of our apartment in New York and beg her to watch the sunset with me.

"I would spend time looking out my window in the early morning, and what I saw was connected in my mind with moods or states of feeling. There is an early morning light, for example, that can remind me of the time in my worst school days—a feeling that the war is on, the dimout. Ahead lies the day. A tight time schedule and I am failing. I feel that in the pit of my stomach.

"Or else it is the feeling of marvelous energy. There is nothing like the beginning of the day." (from *Originals: American Women Artists*)

In *Boy* (FIG. 27) by Jennifer Bartlett, a marble statue of a small boy overlooking an empty pool is seen from three directions against a backdrop of a dark, overgrown garden. Bartlett changes the original motif from one panel to the next, creating her own version of an alternating rhythm. This painting is organized in a series of three panels. The marble statue in the first section gives way to a ghostlike presence in the second. The statue might be mistaken for a

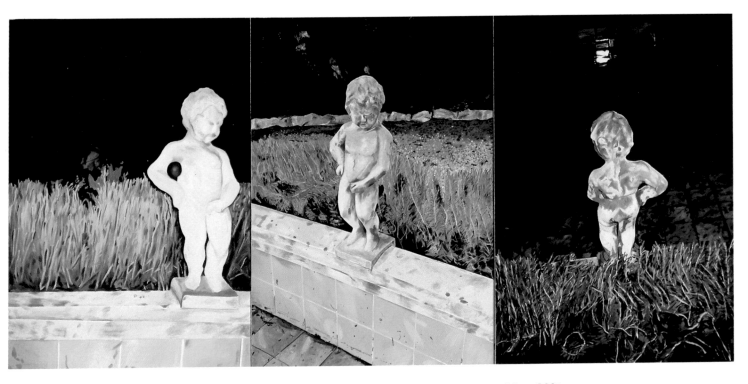

FIG. 27. Jennifer Bartlett, *Boy*, 1983, oil on three canvases, 84″ × 180″.
Nelson-Atkins Museum of Art, Kansas City.

small boy in the third. In this way the subject is disorienting, dreamlike. It is up to the viewer to supply a narrative.

Imagine entering the canvas. What time of day is it? Describe what you see around you. What is hidden? If you look hard enough, the artist seems to be saying, a whole world is contained there.

Bartlett's interest in organizing visual elements into a series developed at an early age.

"I always told everyone I wanted to be an artist. And I kept doing repetitive things. When I saw Disney's Cinderella I made about five hundred drawings of Cinderella with a different trim on every one of her dresses. Or I'd buy lots of those fuzzy chickens you get on Easter, and divide them up by color and put them in pens according to their color. Once I made a series of pictures on brown paper of California missions: missions with Indians in the field; missions with priests; missions in the field; with cliffs; with oceans; with mountains; with boats. Once I drew a fair with every single booth. Anything to do with organization."

(from *Originals: American Women Artists*)

EMPHASIS!

While you are wandering through a meadow on a summer day, your eye is directed to a spot of yellow: One lone sunflower rises tall and spindly against the low green grass. Your attention is riveted by the flower, which contrasts so strongly with the surrounding blanket of green.

Artists accent or highlight features in their paintings by emphasizing certain elements. Emphasis is the result of one part of the painting dominating the other parts, thus capturing the viewer's attention.

In Jasper Johns's *Target with Four Faces* (FIG. 28), our eye is drawn first to the center of the target. Johns proclaims flatness by choosing a shape, the target, that actually is flat, and emphasizes it. Here we concentrate on the circles. They are as mesmerizing as ripples on a pond.

Notice the repetition of the four plaster faces in the wooden frame. Each cast is slightly different. The mouths, noses, and cheeks are painted. Hinges can be seen on the wooden frame. The finished wood contrasts with the painted area. Primary colors limit the palette and reverse the normal representation of a target. The artist works with encaustic, which is hot melted wax mixed with color used instead of paint. Scratches, bits of paper, ridges, and furrows stress the lively surface and handmade look. This contradicts the fact of the target itself, preconceived, stereotypic, and flat. A target can be found at a rifle range as well as in a shooting gallery. But here wooden faces are lined up instead of ducks—a seemingly banal image with an ambiguous, negative twist.

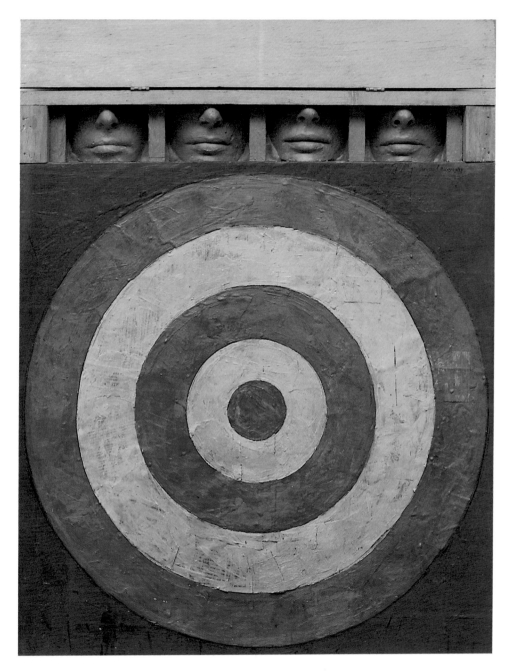

FIG. 28. Jasper Johns, *Target with Four Faces*, 1955,
encaustic and collage on canvas with plaster casts, 29³/₄″ × 26″ × 3³/₄″.
The Museum of Modern Art, New York.

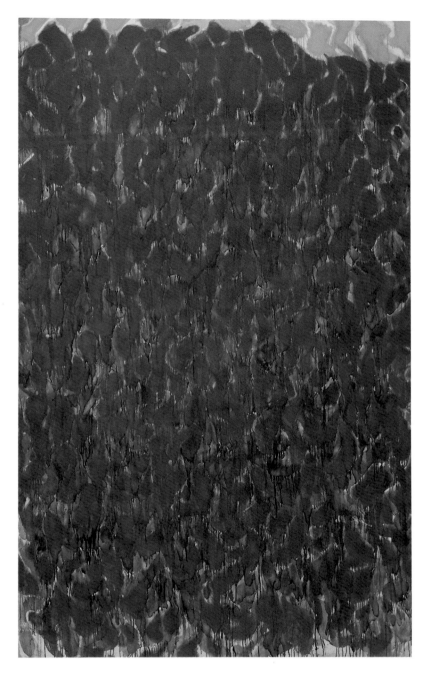

FIG. 29. Sam Francis, *Big Red*, 1953, oil on canvas, 120″ × 76¼″.
The Museum of Modern Art, New York (gift of Mr. and Mrs. David Rockefeller, 1955).

In Sam Francis's *Big Red* (FIG. 29), instead of a central point of interest, the color red dominates the whole canvas. The artist emphasizes red to produce a unified effect. By limiting his color and repeating the red shapes, Francis manipulates the way we look at the parts of this painting, as well as the way we read it as a whole. Notice that red is positive space; blue/black is negative space. Your eye flows easily from one repeated red shape to the next. Dribbles and dabs of paint, rivulets of color stream across the canvas in a continuous pattern. What does it remind you of? Meadows of poppies? Hot coals? Molten lava? Dripping blood? In this allover composition, you can feel the power of red.

A SENSE OF VARIETY

While walking down a busy street, we are bombarded with the smells, sights, and sounds of the city: glaring signboards, the smoky odor of roasted chestnuts, honking cars, and people in assorted sizes and shapes moving at different speeds from all directions. A variety of images sparks our imagination. Variety in art provides contrast and visual interest. You can find the variety of textures (rough/smooth), lines (thick/thin), color (red/blue), or shapes (round/square) in the paintings throughout this book.

Made in Japan (FIG. 30) by Jean-Michel Basquiat is not a portrait of a real person. Instead, Basquiat outlines a skull-like head reminiscent of a machinelike zombie in cartoons. The artist employs a variety of marks and lines. Black squiggles replace the monster's brain with microchip circuitry. The red lines could be wires or printed circuit boards; the blue lines, electrical tubing. A dangerous, deathlike quality is achieved by the jagged network of lines. The childlike simplicity of the shapes and bright colors relates to the graffiti imagery found in New York subways; the sharp lines and machine imagery relate to our technological culture.

FIG. 30. Jean-Michel Basquiat, *Made in Japan*, 1982, oilstick and acrylic on canvas, 60″ × 36″.
Greenberg Gallery, St. Louis.

In Sam Gilliam's metal relief painting *The Saint of Moritz* (FIG. 31) we find triangles, a circle, a half-moon, rectangles, stripes, squares—a symphony of shapes and patterns, of textures and colors. Shades of red—from raspberry and persimmon to peppermint pinks—are at once sleek, then blister and bubble, like the pockmarked texture of Mars. Textures recall the swirling patterns of marbleized paper or cells seen under a microscope. Black and white stripes strut; red triangles hop. Geometric shapes spin in every direction, unified by repeated colors and patterns. A bold variety of shapes is stitched together by crisscrossing bands of red and black—a celebration with a big jazz band sound.

As a child Sam Gilliam lived in a small town in Mississippi, where he remembers drawing all the time:

"My favorite drawing material was the cardboard from laundered shirts because my parents could get it at the laundry down the street; thus I had a ready supply of drawing material. I started to draw quite early because my brother made a lot of drawings and my sister loved to draw paper dolls. I was about five or six years old. When I got into fifth grade, I knew I was going to be an artist. My fifth grade teacher held contests with prizes for the best painting. I was such a frequent winner that she said, 'You know, you should be an artist when you grow up.' I thought about it for only a second and said, 'I think I will.'"

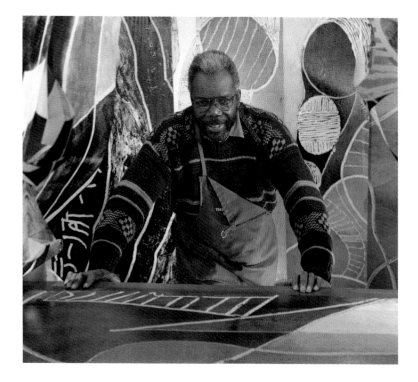

Sam Gilliam at work in his studio.
(© Gregory Conniff, 1990)

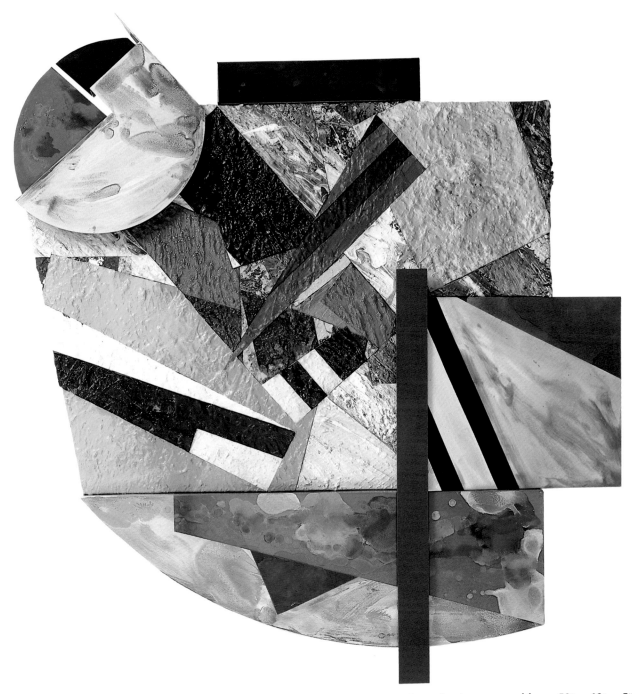

FIG. 31. Sam Gilliam, *The Saint of Moritz*, 1984, acrylic on canvas, enamel on aluminum assemblage, 59" × 63" × 5". De Menil Collection, Houston.

SEEING IT WHOLE

Unity in art fuses the parts of a painting into a satisfactory whole. This fusion is achieved first by the artist and then by the viewer. When you look at a unified work of art, you feel it. If you were to remove one line or shape or color, the painting might fall apart. If you were to add another part, it would be too much. There is such a thing as too much variety or too little. Artists rearrange the elements to find the right combinations, striking a balance between harmony and confusion, between order and chaos.

In Audrey Flack's *Marilyn* (*Vanitas*) (FIG. 32) all the visual elements work together to produce a unified effect. Every object in this large photorealistic painting, from the typed page in the center to the purple satin sheet, lipstick, perfume, compact, photos, beads, and pears, refers to the movie idol Marilyn Monroe. They unify the painting in terms of subject matter as well as composition. Like hot dogs or Elvis Presley, Marilyn is a symbol of our culture. Flack surrounds her with beauty symbols, the tricks of her trade. The variety of items, their contrasting shapes, sizes, colors, and textures, provides continuing interest. The slightly distorted mirror in the elaborate gold frame on the left reflects the larger photo of Marilyn on the right. The black-and-white photos provide balance as well as emphasize the star of this elaborate still life. The artist's repetition of red in various shades produces unity. The rose, pot of lip gloss, candle, lipstick, hourglass, and tablecloth direct our eye around the picture plane. The velvety texture of the delicate rose, the photographs, and the sensuously draped cloth provide a contrast with the glistening blue glass, the silver candlestick, and the beveled perfume bottle. Other textures, shapes, lines, and colors play off one another, unifying the composition.

Even as a student, Audrey Flack wanted to draw realistically. "There is magic," she said, "in being able to capture nature." She was fascinated by objects in her immediate world, by movie stars, and by consumer products. She taught herself to draw by copying or reproducing what was available around her.

''I had to take a test in order to be accepted into the High School of Music and Art [in New York City]. I was instructed to bring a portfolio containing my artwork to the exam. I wasn't quite sure what a portfolio was, but since the dime store had everything, I went there. There was an eight-by-ten brown folder in the stationery section. On its cover in bright gold letters was printed 'PORTFOLIO.' It seemed strange that there were envelopes and writing paper inside; however, I removed them and substituted my drawings instead. I had copied four roses off the label of a whiskey bottle, the old man from Old Grand-dad whiskey, and a picture of Greer Garson in the movie *Mrs. Miniver*. When my father dropped me off for

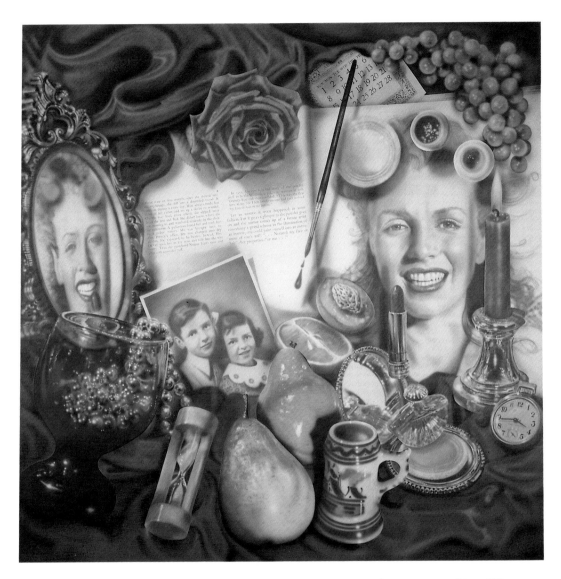

FIG. 32. Audrey Flack, *Marilyn (Vanitas)*, 1977, oil over acrylic on canvas, 96" × 96".
Art Museum of the University of Arizona, Tucson.

the exam, I saw the other students carrying huge black leather cases that I recognized immediately to be portfolios. I felt so embarrassed he had to push me out of the car. I hid my small brown folder under my coat. I guess because I sketched so much, I did well on the drawing part of the exam. I got my ultimate wish; I was accepted!"

A MATTER OF SPACE

Unlike Audrey Flack, who uses a slide/photograph projected on a canvas to reproduce her images faithfully in paint, many of the artists we have discussed have rejected the notion of realism—that a painting should imitate the real world. But whether their art is abstract or realistic, they still make use of many of the same techniques to create perspective or the illusion of depth.

Painters, for the most part, paint on flat, two-dimensional surfaces. To create a three-dimensional effect or a sense of spatial depth, they use various devices including overlapping planes, converging lines, color, scale, size, and placement on the canvas.

Roy Lichtenstein at work in his studio.
(© Hans Namuth, 1980)

THE PAINTER'S EYE

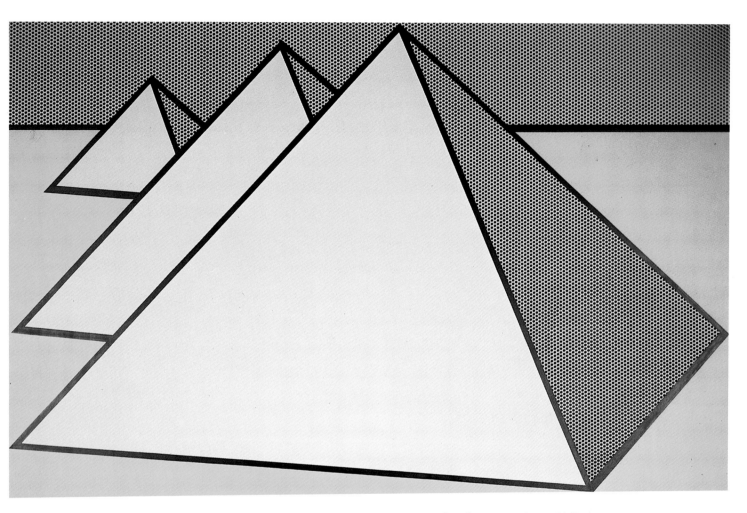

FIG. 33. Roy Lichtenstein, *The Great Pyramid*, 1969, oil and magna, 129″ × 204¼″.
Des Moines Art Center.

One pyramid of *The Great Pyramid* (FIG. 33) overlaps the other so that the largest one seems closer to the viewer. The pyramids are opaque. If they were transparent, this device would not work. Here again Roy Lichtenstein flattens his shapes, outlining them in bold black lines, presenting a fresh, simplified view of this ancient Egyptian monument. It forces us to consider with renewed interest one of the world's most reproduced tourist attractions.

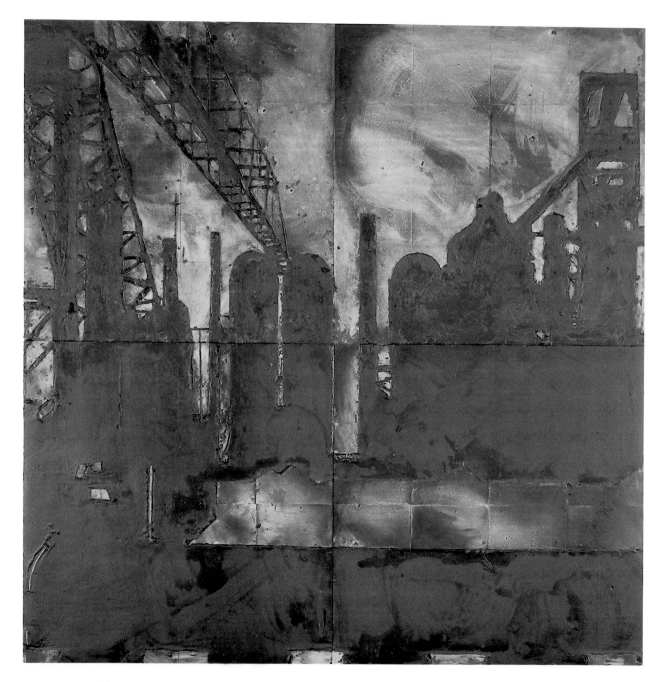

FIG. 34. Donald Sultan, *Plant, May 29, 1985*, latex paint and tar on vinyl composite tile on masonite, 96³/₄″ × 96³/₄″. Hirshhorn Museum, Washington, D.C.

THE PAINTER'S EYE

In *Plant, May 29* (FIG. 34), Donald Sultan uses size, scale, placement on the canvas, and converging lines to give a sense of depth and breadth to the painting. The crane and the cracking tower seem closest to us. These objects are bigger than the silo shapes or smokestacks in the distance. They are also placed higher on the picture plane, looming over the smaller shapes.

Notice that the smokestacks appear far away. The lines of the crane and tower pull our eye into an illusion of deep space. Sultan achieves a sense of distance through diagonal lines and shapes, which gradually converge and seem to recede toward the center of the picture plane to an invisible vanishing point. This is an industrial scene, yet there is a wild, romantic beauty in the swirling atmosphere of smoke and fire.

Donald Sultan at work in his studio.

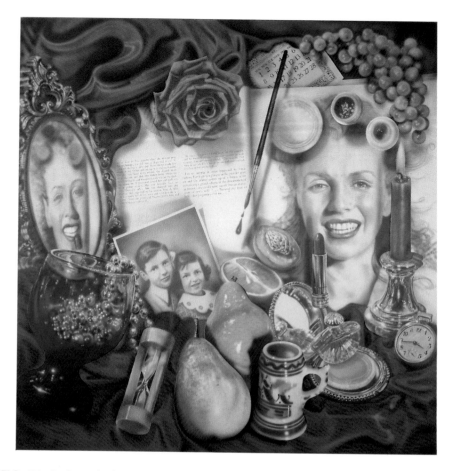

FIG. 35. Audrey Flack, *Marilyn (Vanitas)*, 1977, oil over acrylic on canvas, 96″ × 96″.
Art Museum of the University of Arizona, Tucson.

Hot colors advance; cool colors recede. Bright colors advance; dull colors recede. In Audrey Flack's painting of Marilyn (FIG. 35), the red lipstick in its glittery gold case and the orange fruit come forward, while the dull gray and off-white photograph is clearly behind. Not only color but placement affects the way we see objects on the picture plane. Notice that the colorful objects are placed lower. A shape in the middle of the picture plane (at eye level), in this case the photo of Marilyn, tends to seem more distant than those that are higher or lower.

In this abstract painting, *White Center* (FIG. 36), Mark Rothko creates visual depth with a bright white square on an intense red background. The hazy-edged shapes seem to float in space. This airy sense of depth is called atmospheric perspective. The white appears to ad-

THE PAINTER'S EYE

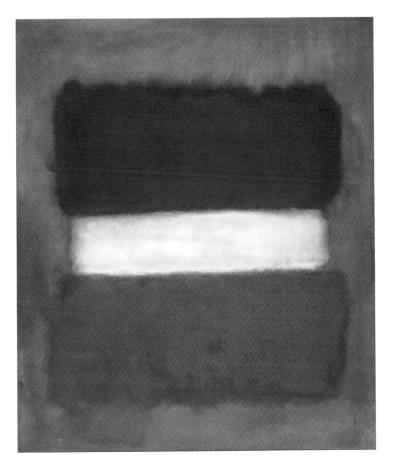

FIG. 36. Mark Rothko, *White Center*, 1957, oil on canvas, 84″ × 72″.
Los Angeles County Museum (David E. Bright bequest).

vance, then recede. The colors blaze like the sun at noon or pulse like the beat of a drum.

Now that we have developed a language of art, examined how a painting is organized into a unified whole, analyzed the way the elements are arranged to make a complete visual statement, we can walk into a gallery of paintings and begin to respond to them on many different levels. We can confront one picture and experience it fully, share our observations and feelings with a friend, and even begin to make critical judgments. We can compare it with other paintings in the room. Is it better or not as good? How does it reflect society's values or the artist's vision? How do we feel about it? The next chapter is a full discussion of a painting, considering some of these questions, putting it all together again.

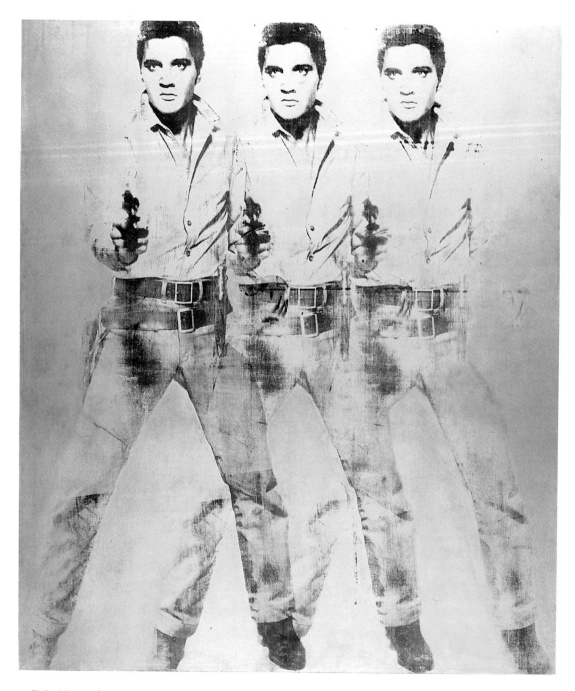

FIG. 37. Andy Warhol, *Triple Elvis*, 1962, silk-screen ink on aluminum paint on canvas, 82″ × 60″. Virginia Museum of Fine Arts, Richmond.

6

PUTTING IT ALL TOGETHER AGAIN— ANDY WARHOL

We've seen this painting before. Remember our two museum-goers in Chapter 1? Let's continue the dialogue, using the language of art. How do the elements and principles work together in *Triple Elvis* (FIG. 37)?

Elvis Presley, dressed as a cowboy, stands in gunslinger stance, pointing a gun at us. His silk-screened photographic image, as straightforward as a movie poster, is repeated three times, larger than life, on a silver background. The texture is flat matte aluminum and black paint with no shading to give a sense of volume. This transparent state reminds us of a film negative, which is reinforced by the repetition of the identical image. The figures seem to flicker in front of our eyes, like a television with bad reception.

There is a rhythmic quality to the repeated triangular shapes of the interlaced legs, but it suggests decoration, not movement. The figures could be a frieze or a border motif. They are anchored firmly to the silvery ground by the double gun holster and belt around Elvis's waist, the staccato punctuation of the gun barrel, repeated by the equally emphatic and intense eyes. The image came from a movie poster. Now blown up, taken out of context, Elvis faces the viewer, gun pointed, and demands our attention.

Movie star, rock and roll, hero, cult figure, Hollywood, sex, the Old West, myth, advertising poster, the King: These aren't threatening words. The violence promised by the pointed gun is offset by the familiar, softly handsome face with its sexy but honest gaze. We assume this Elvis is on the side of right, our side, protecting the weak, the innocent, us.

If you were going to write a dialogue to go with this painting, what would it be?

"All right. Hand over the wallet, sucker." Not likely.

How about "Put up your hands, you lying, cheating, lowdown varmint"? That's more like it.

Yet we know Elvis wasn't a real cowboy, did not threaten villains with a six-gun, and was unlikely to rescue us from anything but boredom. He's acting, playing out a role, playing on our fantasies. Warhol was interested in painting not a portrait of the "real" Elvis, but one of Elvis as "movie star" or "hero" appearing at your neighborhood theater, on your television screen. This is a portrait of Elvis as a pop culture hero, the rock star playing cowboy, another hero out of our American mythology. That's why our museumgoers summed up the painting with the phrase "He really was the King." On this level we "get" this image almost without even thinking about it.

We can't guess from this painting if Andy Warhol liked or didn't like Elvis, his music, or his movies. He seems to be implying his opinion isn't important. The artist's interest is in the public's perception of Elvis, and in showing us Elvis as a symbol or icon of the society in which he lived.

The repetition of the Elvis figure serves another purpose. By repeating the image, the artist has underlined Elvis as consumer goods. This Elvis is as much a product for public consumption, designed to appeal to popular taste, as the Campbell's soup cans and Coca-Cola bottles Warhol also painted.

Warhol wrote,

"Sometimes you fantasize that people who are really up there and rich and living it up have something you don't have, and their things must be better than your things because they have more money than you. But they drink the same Coke and eat the same hot dogs and wear the same clothes and see the same TV and the same movies. . . . You can get just as revolted as they can—you can have the same nightmares. All this is really American."

—from *The Philosophy of Andy Warhol (from A to B and Back Again)*

Andy Warhol photographing Margaret Hamilton, costumed as the Wicked Witch of the West, in preparation for making a photo silk screen.
(© Barbara Goldner, 1980)

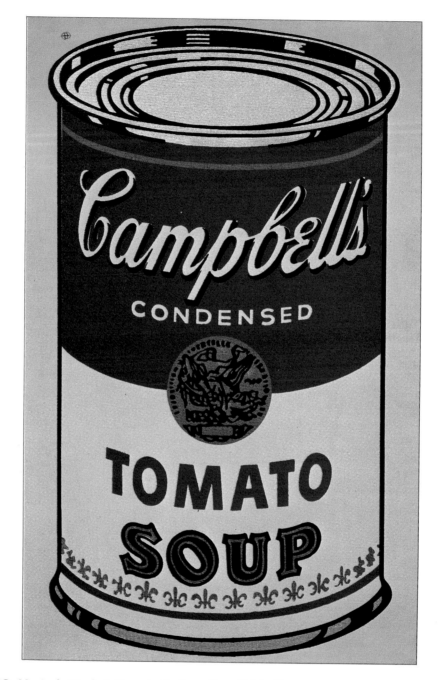

FIG. 38. Andy Warhol, *Campbell's Soup Can,* **1964, silk screen on canvas, 34³/₄″ × 24″.**
Leo Castelli Gallery, New York.

The *Campbell's Soup Can* (FIG. 38) may be Andy Warhol's most famous image. The supermarkets are full of soup cans in every conceivable flavor: tomato, vegetable, chicken. Is this a serious subject for art? Yet once we really have looked, once we have paid attention to that big soup can on the museum wall, what happens the next time we push our cart down the grocery store aisle past the soup display? Whether we liked the painting of the soup can or not, Andy Warhol makes us see our old lunchtime friend in a new way: the shape of the can, solid and compact, pleasingly proportioned, the color of the label, the crisp contrast of red and white. Here the ordinary details of our daily life are glorified by art.

The artist has changed the way we experience the world, has said, "This is what I see. What do you see?" And by looking and thinking, whether or not we ourselves ever pick up a brush and paint, we begin to look with a different eye, a painter's eye, not just in museums and galleries but in the world around us. And that, in the end, is what it's all about.

ARTISTS' BIOGRAPHIES

(The artists are grouped alphabetically under the movement they are or were identified with most closely. At the end of each biography you will find a list of some museums where other paintings by these artists can be seen.)

In the last nine decades of the twentieth century, decades of extraordinary invention and growth, American painting has come into its own. Mass production, industrialization, new technology, rapid transit, and hundreds of other scientific discoveries transformed cities across the country. American artists responded to these changes. Progressing through a variety of experiments, both influenced by and reactions against their European counterparts, a group of artists emerged in the 1940s and 1950s with a revolutionary new style called abstract expressionism. These artists dazzled the international art world with their large, vibrant abstract paintings. As a result of these groundbreaking images, New York, instead of Paris, became the center of artistic activity.

Like the pioneers who explored and settled the frontier, American artists are adventurous and energetic. Their diverse works reflect this energy. By experimenting with bold new forms and materials, they challenge us to rethink our attitudes about art and the human condition.

ABSTRACT EXPRESSIONISM

The abstract expressionists abandoned the idea that painting is a picture window looking into the real world. To these artists and others who followed them, three-dimensional effects in painting were sheer illusion. A painting to them was a flat surface with paint on it, an object to be appreciated for its own sake. The subject matter of these paintings is not a realistic im-

age, as in a portrait or still life. The subject matter is color or line or shape or texture, or the relationships among these elements. The artists use color or line to translate their emotions on canvas, stressing risk and unpredictability, thus capturing the mood and rhythm of contemporary life.

WILLEM DE KOONING
 Born 1904, Rotterdam, the Netherlands.
 Studied at Academie voor Beeldende Kunsten ed Technischen Wetenschappen, Amsterdam. Came to United States in 1926. Worked as a commercial artist and house painter. Later taught at Black Mountain College and Yale University.
 His energetic brushstroke and the vitality of his paintings influenced several generations of painters.
Art Institute of Chicago, Illinois; Neuberger Museum, State University of New York at Purchase, New York; Albright-Knox Gallery, Buffalo, New York; Cleveland Museum of Art, Ohio; Carnegie Institute of Art, Pittsburgh, Pennsylvania.

SAM FRANCIS
 Born 1923, San Mateo, California.
 Studied at the University of California, B.A. and M.A.
 A second generation abstract expressionist, Francis imbues his paintings with a sense of joy and celebration.
Mural, General Services Administration Building, Anchorage, Alaska; The Oakland Museum, California; Albright-Knox Gallery, Buffalo, New York; Dayton Art

Institute, Ohio, Modern Art Museum of Fort Worth, Texas; Seattle Museum of Art, Washington.

ROBERT MOTHERWELL
Born 1915, Aberdeen, Washington.

Studied at Stanford University, B.A., California School of Fine Arts, and Harvard University.

Motherwell's monumental statements often incorporate geometric and organic shapes, which communicate symbolic meanings.

San Francisco Museum of Modern Art, California; Hirshhorn Museum and Sculpture Garden, Smithsonian Institution, Washington, D.C.; Addison Art Gallery, Phillips Academy, Andover, Massachusetts; Walker Art Institute, Minneapolis, Minnesota; Cleveland Museum of Art, Ohio; The Chrysler Museum, Norfolk, Virginia.

JACKSON POLLOCK
Born 1912, Cody, Wyoming; died 1956, The Springs, New York.

Studied at the Art Students League, New York.

His large paintings, in which he dripped and poured paint on canvas spread on the floor, are considered the most startling and influential paintings of his generation. Drip painting, action painting, and gestural painting are some of the terms that critics have applied to Pollock's unrestrained creations.

San Francisco Museum of Modern Art, California; University of Iowa Museum of Art, Ames, Iowa; Joslyn Art Museum, Omaha, Nebraska; Brooklyn Museum of Art, New York; Museum of Art, R.I.S.D., Providence, Rhode Island; Menil Collection, Houston, Texas.

MARK ROTHKO
Born 1903, Dansk, Russia; died 1970, New York.

Studied at Yale University and the Art Students League, New York.

Rothko stained into the canvas with a large brush—oblongs floating within rectangles—producing an atmospheric, pulsating effect.

University Art Museum, University of California, Berkeley, California; The Museum of Modern Art, New York, New York; Museum of Art, R.I.S.D., Providence, Rhode Island; Museum of Fine Arts, Houston, Texas.

Here are some of the various movements in American art that came after abstract expressionism.

COLOR FIELD PAINTING— POST PAINTERLY ABSTRACTION

The thinned paint used by Helen Frankenthaler and Morris Louis gives a flat look to the canvas. Both artists stained paint into the canvas, so that the unprimed cotton duck itself became part of the composition and enhanced the feeling of flat veils of color. The lack of brushstroke was a way of reacting to the thick gestures of paint favored by abstract expressionists. The painting becomes a field of color, occupying the whole surface of the canvas.

HELEN FRANKENTHALER
Born 1928, New York.
Studied at Bennington College, B.A.

Through her stain technique of pouring thinned paint onto unprimed canvas spread on the floor, Frankenthaler achieves a harmonious balance of figure, ground, and color.

Pasadena Art Museum, California; Baltimore Museum

of Art, Maryland; Museum of Fine Art, Boston, Massachusetts; Cooper Hewitt Museum, New York, New York; Everson Museum, Syracuse, New York; Carnegie Institute of Art, Pittsburgh, Pennsylvania.

MORRIS LOUIS
Born 1912, Baltimore; died 1962, Washington, D.C.
Studied at the Maryland Institute.

Louis had nine prolific years, working in Washington, D.C., in which his most famous series of color field paintings—the veils, unfurled, and stripes—were completed. These works are expressions of feeling, from joyous to sublime.

National Gallery of Art, Washington, D.C.; Des Moines Art Center, Iowa; Sheldon Memorial Art Gallery, University of Nebraska, Lincoln, Nebraska; Guggenheim Museum, New York, New York; Museum of Fine Arts, Houston, Texas.

MINIMALISM and GEOMETRIC ABSTRACTION

These preconceived paintings, often geometric and abstract, explore the relationships between color and form and are a reaction to the spontaneous brushwork of the abstract expressionists. These paintings vary from the pared-down oddly shaped canvases of Ellsworth Kelly to the more decorative metal reliefs of Frank Stella.

SAM GILLIAM
Born 1933, Tupelo, Mississippi.
Studied at the University of Louisville, B.A., M.A.
Most recently his decorative abstractions exhibit an exciting play of materials, color, texture, and form. His earlier works, draped canvases, splattered with paint, refer back to abstract expressionism.

Denver Art Museum, Colorado; Wadsworth Atheneum, Hartford, Connecticut; Phillips Collection, Washington, D.C., Art Institute of Chicago, Illinois; Baltimore Museum of Art, Maryland; Walker Art Center, Minneapolis, Minnesota; North Carolina Museum of Art, Raleigh, North Carolina.

ELLSWORTH KELLY
Born 1923, Newburgh, New York.
Studied at the Boston Museum School and the Académie des Beaux-Arts, Paris.

Kelly makes pictures that deal directly with color and shape. The surface of his canvas is flat, containing fields of color rigidly divided. This is a departure from Rothko's fuzzy division of shapes, yet in Kelly's paintings the color and shapes interact to create a vibrating or pulsating effect as well. The canvas itself becomes the object rather than an arena for expressing psychological content.

La Jolla Museum of Contemporary Art, California; Washington Gallery of Modern Art, D.C.; Art Institute of Chicago, Illinois; Worcester Art Museum, Massachusetts; Carnegie Institute of Art, Pittsburgh, Pennsylvania; Seattle Museum of Art, Washington.

FRANK STELLA
Born 1935, Malden, Massachusetts.
Studied at Princeton University.

He was not as concerned with color as he was with the idea of the painting as object, a thing existing in its own right. His all-black paintings patterned with parallel stripes came first and later developed into shaped canvases. In the 1980s he abandoned minimalism in

favor of dramatic metal reliefs with various connected parts.

San Diego Museum of Art, California; Santa Barbara Museum of Art, California; Walker Art Center, Minneapolis, Minnesota; St. Louis Art Museum, Missouri; Metropolitan Museum of Art, New York, New York; Allen Memorial Art Museum, Oberlin, Ohio.

POP ART

A distancing or cool detachment characterizes the works of the minimalists as well as those of the pop artists. Pop art was a reaction against abstract painting and emerged in the late fifties and early sixties, celebrating postwar consumerism. These artists depicted realistic subject matter, most notably common objects, with irony and wit. Just as the impressionists recorded street life in turn-of-the-century Paris, the pop artists provided an instant chronicle of what mattered most to people in the sixties and seventies.

JASPER JOHNS
Born 1930, Augusta, Georgia.
Studied at the University of South Carolina.
Johns, along with Robert Rauschenberg, bridged the gap between the abstract expressionists and the pop artists.
They incorporated the free brushwork of action painters with common objects. Johns utilizes common objects in his work: a set of numbers, a target, a map of the United States, or an American flag.
Museum of Ancient and Modern Art, Nevada City, California; San Francisco Museum of Modern Art, California; Wadsworth Atheneum, Hartford, Connecticut; Yale University Art Gallery, New Haven, Connecticut;

Guggenheim Museum, New York, New York; Philadelphia Museum of Art, Pennsylvania.

ROY LICHTENSTEIN
Born 1923, New York.
Studied at Ohio State University, M.F.A.
Lichtenstein is famous for his brash paintings of comic strips, blown up and out of context, which explore the formal issues of paintings as well as the ironies of contemporary culture. Many of his paintings are adapted from the work of artists of the past, reworked and simplified in bold two-dimensional terms.
Norton Simon Museum of Art, Pasadena, California; Miami Beach Theater of the Performing Arts, Florida; Art Institute of Chicago, Illinois; Detroit Institute of Art, Michigan; Brooklyn Museum of Art, New York; Fort Worth Art Museum, Texas.

ROBERT RAUSCHENBERG
Born 1925, Port Arthur, Texas.
Studied at the Kansas City Art Institute and Black Mountain College.
Rauschenberg, whose interests extend beyond painting and sculpture to happenings, dance, and stage design, explores the connections between art and life in his imaginative, experimental artworks.
Los Angeles County Museum of Art, California; National Gallery of Canada, Ottawa, Canada; Art Gallery of Ontario, Toronto, Canada; Nelson-Atkins Museum of Art, Kansas City, Missouri; Albright-Knox Gallery, Buffalo, New York; Cleveland Museum of Art, Ohio.

JAMES ROSENQUIST
Born 1933, Grand Forks, North Dakota.
Studied at the University of Minnesota and the Art Students League, New York.

Formerly a billboard painter, he presents bright deadpan large-scale montages that explore the commercialism and industrialization of contemporary life.

National Museum of American Art, Washington, D.C.; Museum of Art, Ft. Lauderdale, Florida; Jacksonville Art Museum, Florida; Albright-Knox Gallery, Buffalo, New York; The Museum of Modern Art, New York, New York.

WAYNE THIEBAUD

Born 1920, Mesa, Arizona.
Studied San Jose State College and Sacramento State College, B.A., M.A. Teaches in California.

He started as a commercial artist and sign painter. Although Thiebaud often paints figures and landscapes, he is best known for his depictions of everyday objects, such as toys, pies, hats, and hot dogs, set apart and glorified through his sensuous paint surfaces.

Phoenix Art Museum, Arizona; Crocker Art Museum, Sacramento, California; Library of Congress, Washington, D.C.; Philadelphia Museum of Art, Pennsylvania; Museum of Fine Arts, Salt Lake City, Utah; Virginia Museum of Fine Arts, Richmond, Virginia.

ANDY WARHOL

Born 1928, McKeesport, Pennsylvania; died 1987, New York.
Studied at Carnegie Tech, B.F.A.

Warhol, one of the prime movers of the pop art movement, transformed the icons of our popular culture into art, most often through silk-screened repetitive images. He was also a filmmaker and the publisher of *Interview* magazine.

La Jolla Museum of Contemporary Art, California; Art Gallery of Ontario, Toronto, Canada; Museum of Fine Arts, Boston, Massachusetts; Detroit Institute of Arts,

Michigan; Carnegie Museum of Art, Pittsburgh, Pennsylvania; Fort Worth Art Museum, Texas; The Menil Collection, Houston, Texas.

TOM WESSELMANN

Born 1931, Cincinnati, Ohio.
Studied at the Art Academy of Cincinnati.

He trained as a cartoonist and later began to develop his ironic pop imagery through his *The Great American Nude* series, made of mixed media, paint, and plastic.

Worcester Art Museum, Massachusetts; Minneapolis Institute of Art, Minnesota; Nelson-Atkins Museum of Art, Kansas City, Missouri; University of Nebraska Art Galleries, Lincoln, Nebraska; Cincinnati Art Museum, Ohio; Dallas Museum of Fine Arts, Texas.

SUPERREALISM

These artists took the realistic image one step further in their near-photographic depictions of the American scene.

AUDREY FLACK

Born 1931, New York.
Studied at Cooper Union and Yale University, B.F.A.

Her still lifes, often tabletops filled with an eclectic mix of objects, cosmetics, toys, jewelry, or food, are arranged carefully, photographed, and painted from slides projected on canvas. She is currently working on large-scale sculpture and plays the banjo in a band called the Art Attacks.

San Francisco Museum of Fine Art, California; National Museum of Women's Arts, Smithsonian Institution, Washington, D.C.; Rose Art Museum, Brandeis

University, Waltham, Massachusetts; St. Louis Museum of Art, Missouri; Whitney Museum, New York, New York.

OP ART

These artists were primarily concerned with colorful geometric patterns to create optical illusions. To achieve these illusions, they concentrated on precise color relationships, which produce surprising kinetic effects.

RICHARD ANUSZKIEWICZ
 Born 1934, Erie, Pennsylvania.
 Studied at the Cleveland Institute of Art, B.F.A., and Yale University, M.F.A.
 At the end of the abstract expressionist movement, this artist developed geometric compositions of luminous color that investigate figure/ground relationships.
Fogg Art Museum, Cambridge, Massachusetts; Currier Gallery of Art, Manchester, New Hampshire; New Jersey State Museum, Trenton, New Jersey; Butler Institute of American Art, Youngstown, Ohio; Chattanooga Art Association, Tennessee; Virginia Museum of Fine Arts, Richmond, Virginia.

NEW IMAGISM and Other Developments

The younger generation of artists in the 1980s explored all areas from abstract to realistic, intellectual to emotional paintings. Their concerns went from stylistically crude, funky paintings to almost childlike, native images, often with private or personal references. They were reacting against the glorification of pop culture.

JENNIFER BARTLETT
 Born 1941, Long Beach, California.
 Studied at Mills College and Yale University, M.F.A.
 Using materials such as baked enamel on steel plates, canvas and paint, and wood constructions, she explores various themes through serial imagery.
Walker Art Center, Minneapolis, Minnesota; Akron Art Museum, Ohio; Allen Memorial Art Museum, Oberlin, Ohio; Brooks Memorial Art Gallery, Memphis, Tennessee; Museum of Fine Arts, Dallas, Texas.

JEAN-MICHEL BASQUIAT
 Born 1960, New York; died 1988, New York.
 His graffitilike images often refer to his Haitian and Puerto Rican heritage and demonstrate the artist's involvement with the urban environment.
Los Angeles Museum of Contemporary Art, California; Museum of Contemporary Art, Chicago, Illinois; Detroit Institute of Art, Michigan.

DONALD SULTAN
 Born 1951, Asheville, North Carolina.
 Studied at the University of North Carolina, B.F.A., and the Art Institute of Chicago, M.F.A.
 A painter and printmaker, Sultan uses tar and tile, incorporating recognizable images, often still lifes, and industrial scenes.
The High Museum of Art, Atlanta, Georgia; Art Institute of Chicago, Illinois; Metropolitan Museum of Art, New York, New York; Ackland Art Museum, University of North Carolina, Chapel Hill, North Carolina; Toledo Museum of Art, Ohio.

GLOSSARY

(Terms that relate to *color* and *space* are grouped under these headings, not alphabetically.)

abstract art: art in which the elements—line, shape, texture, or color—rather than a recognizable object have been stressed.

Ben Day process: a method of separating color for printing, which results in the printed image being composed of many small dots, sometimes quite fine, sometimes coarse.

canvas: a fabric or surface on which an artist applies paint.

collage: the use of paper or other flat materials to form a picture or design. The artist uses real objects or manmade objects, which bring to the picture its own particular texture. Artists often use natural objects, such as leaves or twigs, to incorporate in their paintings.

color: "a sensation experienced usually as a result of light of varying wavelengths reaching the eye," according to *Webster's Dictionary.* Color has three attributes: hue, intensity, and value.

> **hue:** the six pure colors—red, orange, yellow, green, blue, violet.
>> **primary colors:** red, yellow, blue.
>> **secondary colors:** green, violet, orange. The secondary colors are made by mixing two primary colors together. Blue and yellow combine to make green.

intensity: The degree of strength or saturation of a color. Intensity refers to the brightness or dullness of a hue (color). The intensity of a hue is lowered or made duller by adding the color opposite it on the color wheel. For example, if you add some green to bright red, the red becomes less bright.

value: the lightness or darkness of a color. The value of a hue (color) is changed by the addition of white or black. Shape, line, and texture also can affect value contrasts.

> **neutral:** tones of black, white, gray.
> **shade:** one of the hues plus black.
> **tint:** one of the hues plus white.
> **analogous colors:** three colors that are next to each other on the color wheel, such as red, red orange, and orange. Analogous colors produce a harmonious effect.

complementary colors: colors opposite each other on the color wheel. If you mix two primary colors together to get a secondary color, that color is the complement of the primary color you didn't use. For example, if you mix red and blue to get purple, yellow is its complementary color. When complementary colors are placed side by side, they have a strong effect on each other.

combine painting: transforming nonart materials and objects into art, as in Robert Rauschenberg's *Bed.*

Assemblage is another term for a combine painting.

common object: ordinary objects of daily life, such as soup cans or lipsticks, that are the subjects or materials used in art.

composition: the organization of form in a work of art.

This general term refers to the relation of shape, line, and color across the flat two-dimensional surface of a painting.

field: a large flat area of color, often the background of a painting.

figurative: realistic or at least recognizable painting of a human subject or inanimate object.

foreground: that which appears at the front of the picture plane in a painting.

frieze: a decorative horizontal band.

illusion: the use of various painterly techniques to create a representational appearance of reality.

kinetic: either the appearance of movement or action/motion in a painting with moving parts.

landscape: a painting from or based on nature in which scenery is the dominant subject.

line

 horizontal line: a straight line that goes across the canvas.

 vertical line: a straight line that goes up and down.

op art: the style of art in which line, shape, and/or color cause an optical illusion on the surface of the canvas.

picture plane: the flat surface on which the artist executes an image or the imaginary two-dimensional surface of the painting.

pop art: the style of art in which the subject matter features images from popular culture—advertising, cartoons, or commercial art.

portrait: a painting of a person intended to convey a likeness of character or appearance.

realistic art: painting with a recognizable subject that imitates life.

shaped canvas: a painting that is an unconventional form, such as Sam Gilliam's *The Saint of Moritz* or Frank Stella's *Red with Yellow Triangle*.

silk-screen process: a stenciled process of color reproduction, often used commercially.

space

 perspective: a linear system by which an illusion of depth is achieved on a two-dimensional surface and by which the space is organized from a certain point of view.

 atmospheric perspective: the effect of distance in a painting created by using paler or less intense colors to give a faraway effect.

 negative space: empty areas in a painting or sculpture.

 positive space: the enclosed area surrounded or defined by negative space. Figure/ground is another way of talking about positive/negative space.

still life: a painting of inanimate objects, such as fruit, flowers, or common household objects.

vanishing point: a point in the distance where parallel lines appear to meet.

LIST OF PAINTINGS

Richard Anuszkiewicz, *Sol II*, 1965, acrylic on canvas, 84" × 84". Milwaukee Art Center Collection, gift of the Friends of Art (Photo Nieuhaus/Walls), © Richard Anuszkiewicz/VAGA NY 1990.

Jennifer Bartlett, *Boy*, 1983, oil on three canvases, 84" × 180". Nelson-Atkins Museum of Art, Kansas City, gift of the Friends of Art. © W.R. Nelson Trust (Photo Museum).

Jean-Michel Basquiat, *Made in Japan*, 1982, oilstick and acrylic on canvas, 60" × 36". Greenberg Gallery, St. Louis (Photo Greenberg Gallery).

Willem de Kooning, *Woman on a Bicycle*, 1952–53, oil on canvas, 76½" × 49". Collection of Whitney Museum of American Art, New York. © Willem de Kooning/VAGA NY 1990 (Photo © 1984 Steven Sloman).

Audrey Flack, *Marilyn* (*Vanitas*), 1977, oil over acrylic on canvas, 96" × 96". University of Arizona Museum of Art, museum purchase with funds provided by the Edward J. Gallagher, Jr., Memorial Fund (Photo Museum).

Sam Francis, *Big Red*, 1953, oil on canvas, 120" × 76¼". The Museum of Modern Art, New York, gift of Mr. and Mrs. David Rockefeller, 1955 (Photo Museum).

Helen Frankenthaler, *Flood*, 1967, acrylic on canvas, 124" × 140". Collection of Whitney Museum of American Art, New York, purchase with funds from Friends of the Whitney Museum of American Art (Photo Geoffrey Clements).

Sam Gilliam, *The Saint of Moritz*, 1984, acrylic on canvas, enamel on aluminum assemblage, 59" × 63" × 5". Courtesy of the Menil Collection, Houston (Photo Museum).

Jasper Johns, *Target with Four Faces*, 1955, encaustic and collage on canvas with plaster casts, 29¾" × 26" × 3¾". The Museum of Modern Art, New York, gift of Mr. and Mrs. Robert Scull (Photo Museum).

Ellsworth Kelly, *Spectrum II* (*Thirteen Panels*), 1966–67, oil on canvas, 80" × 273". St. Louis Art Museum, funds given by the Shoenberg Foundation, Inc. (Photo Museum).

Yellow with Red Triangle, 1973, oil on canvas, 305 cm. × 306 cm. In the collection of The Corcoran Gallery of Art, Washington, D.C., museum purchase with the aid of funds from The Richard King Mellon Foundation, 1977 (Photo Museum).

Roy Lichtenstein, *Blam*, 1962, oil on canvas, 68" × 80". Yale University Art Gallery, New Haven, Collection of Richard Brown Baker (Photo Michael Agee, Museum).

The Great Pyramid, 1969, oil and magna, 129" × 204¼". Des Moines Art Center, Iowa, purchased with funds from the Coffin Fine Arts Trust, Nathan Emery Coffin Collection of the Des Moines Art Center (Photo F. J. Thomas).

Reflections: Art, 1988, oil and magna on canvas, 44¼" × 76¼". Leo Castelli Gallery, New York. © Roy Lichtenstein/VAGA 1990 New York.

Morris Louis, *Blue Veil*, 1958, 100½" × 149". Fogg Art Museum, Harvard University, Cambridge, Massachusetts, gift of Lois Orswell and Gifts for Special Uses Fund (Photo Museum).

Robert Motherwell, *The Voyage*, 1949, oil on tempura on paper mounted on composition board, 48" × 94". The Museum of Modern Art, New York, gift of Mr. and Mrs. John D. Rockefeller III (Photo Museum).

Jackson Pollock, *Number 1, 1950* (also known as *Lavender Mist*), oil, enamel, aluminum on canvas, 87" × 118". National Gallery of Art, Washington, D.C., Ailsa Mellon Bruce Fund (Photo Museum).

Robert Rauschenberg, *Bed*, 1955, combine painting, 74" × 71". The Museum of Modern Art, New York, gift of Leo Castelli in honor of Alfred H. Barr, Jr. (Photo Museum). © Robert Rauschenberg/VAGA NY 1990.

James Rosenquist, *House of Fire*, 1981, oil on canvas, 78" × 198". Metropolitan Museum of Art, New York, purchase George A. and Arthur Hoppock Hearn Funds and Lila Acheson Wallace gift. © James Rosenquist/ VAGA New York 1990.

Mark Rothko, *Number 61* (*Brown, Blue, Brown on Blue*), 1953, oil on canvas, 116" × 92". Museum of Contemporary Art, Los Angeles, Collection of Count Panza di Biumo (Photo Squidds and Nunns).

White Center, 1957, oil on canvas 84" × 72". Los Angeles County Museum, David E. Bright bequest (Photo Museum).

Frank Stella, *Fez I*, 1964, fluorescent alkyd on canvas, 77" × 77". Albright-Knox Art Gallery, Buffalo, New York, gift of Seymour H. Knox (Photo Museum).

Il Dimezzato, 1987, painted aluminum, 88" × 95¾" × 53⅜". Greenberg Gallery, St. Louis (Photo Greenberg Gallery).

Donald Sultan, *Plant, May 29*, 1985, latex paint and tar on vinyl composite tile on masonite, 96¾" × 96¾". Hirshhorn Museum and Sculpture Garden, Smithsonian Institution, Washington, D.C., Thomas M. Evans, Jerome L. Green, Joseph H. Hirshhorn and Sydney and Francis Lewis Purchase Fund.

Wayne Thiebaud, *Five Hot Dogs*, 1961, oil on canvas, 18" × 24". Collection of John Bransten, San Francisco (Photo University Art Museum, Berkeley, California).

Andy Warhol, *Campbell's Soup Can*, 1964, silk screen on canvas, 34¾" × 24". © 1990 The Estate and Foundation of Andy Warhol/ARS NY (Photo courtesy of Leo Castelli Gallery).

Triple Elvis, 1962, silk-screen ink on aluminum paint on canvas, 82" × 60". Virginia Museum of Fine Arts, Richmond, gift of Sydney and Francis Lewis (Photo Museum).

Tom Wesselmann, *Bedroom Painting #7*, 1967–69, oil on canvas, 78" × 87", Philadelphia Museum of Art, The Adele Haas Turner and Beatrice Pastorious Turner Fund (Photo Museum). © Tom Wesselmann/VAGA NY 1990.

BIBLIOGRAPHY

Broudy, Harry S. *Enlightened Cherishing: An Essay on Aesthetic Education*. The 1972 Kappa Delta Pi Lecture. Urbana: University of Illinois Press, 1972.

Chip, B. Herschel. *Theories of Modern Art*. Berkeley: University of California Press, 1972.

Feldman, Edward Burke. *Art as Image and Idea*. Englewood Cliffs, N.J.: Prentice-Hall, Inc., 1967.

Final Report to the Rockefeller Foundation on the Aesthetic Education Program at Webster University: Judith Aronson, Ph.D., and Ed Mikel (editors). St. Louis, Mo.: CEMREL, 1976.

Franc, Helen M. *An Invitation to See: 125 Paintings from The Museum of Modern Art*. New York: The Museum of Modern Art, 1973.

Hastie, Reid, and Christian Schmidt. *Encounter with Art*. New York: McGraw-Hill Book, 1969.

How Many Ways Can You Look at a Turtle? St. Louis, Mo.: Aesthetic Education Program CEMREL, Inc., 1974.

Hunter, Sam. *American Art of the 20th Century*. New York: Harry N. Abrams, Inc., 1972.

Hurwitz, Al, and Stanley S. Madeja. *The Joyous Vision: Source Book*. Englewood Cliffs, N.J.: Prentice-Hall, Inc., 1977.

McCoubrey, John W. *American Tradition in Painting*. New York: George Braziller, 1963.

Munro, Eleanor. *Originals: American Women Artists*. New York: Touchstone/Simon and Schuster, Inc., 1982.

O'Doherty, Brian. *American Masters: The Voice and the Myth*. Photographs by Hans Namuth. New York: Universe Books, 1988.

Possibilities I. Winter. New York, 1947–48.

Ragens, Rosalind. *ArtTalk*. Encino, Cal.: Glencoe Publishing Co., 1988.

Read, Herbert. *Education Through Art*. London: Faber and Faber, 1958.

Rose, Barbara. *American Painting: Twentieth Century*. New York: Rizzoli International, 1986.

Russell, John. *The Meaning of Modern Art*. New York: Harper and Row, 1981.

Sims, Patterson. *Whitney Museum of Art Catalogue*. New York: Whitney Museum of Art in association with W.W. Norton, 1985.

Stitch, Sidra. *Made in the U.S.A.: An Americanization in Modern Art: The 50's & 60's*. Berkeley and Los Angeles: University of California Press, 1987.

Tomkins, Calvin. *Post-to-Neo: The Art World of the 1980's*. New York: Henry Holt Company, Inc., 1988.

FURTHER READING

Here are some books that you may find useful as you continue looking at and making art. You can find most of these books in stores and all of them in most libraries.

Atkins, Robert. *Art Speak: A Guide to Contemporary Ideas, Movements and Buzzwords*. New York: Abbeville Press, 1990. Grades 7 and up. This book will help you identify the artist, movements, and terminology pertaining to contemporary art since World War II. This is a good who, where, when, and what book.

Edwards, Betty. *Drawing on the Right Side of the Brain: A Course in Enhancing Creativity and Artistic Confidence*. Los Angeles: J.P. Tarcher, 1989. Grades 6 and up and teachers. Hands-on activities that loosen the mind and the fingers for drawing. A systematic approach to making art that works.

Finn, David. *How to Visit a Museum*. New York: Harry N. Abrams, 1985. Paper. Grades 7 and up. How to make museum visits meaningful through the personal observations of a photographer-writer discussing his favorite works.

Glubok, Shirley. *The Art of America Since World War II*. New York: Macmillan, 1976. (Out of print.) Grades 4–6. A clear and readable introduction to contemporary art using an art historical approach.

Keightley, Moy. *Investigating Art: A Practical Guide for Young People*. New York: Facts on File, 1976. Grades 5 and up. By focusing on the elements and principles, this book will guide you through a variety of detailed activities for making art. It is filled with creative projects that are fun to do.

Jansen, H. W., and Anthony F. Jansen. *History of Art for Young People*. New York: Harry N. Abrams, 1987. Grades 6 and up. This is an overview of the entire scope of Western art and architecture from ancient Egypt to the present. This is a good source book with illustrations, time charts, and short summaries on various art historical developments.

Moore, Janet Gaylord. *The Many Ways of Seeing: An Introduction to the Pleasures of Art*. Cleveland: World Publishing Company, 1968 (out of print). Grades 7 and up. This book sharpens visual awareness by exploring the language of art as well as by suggesting simple exercises for drawing. A wide range of illustrations and reproductions provides visual clues and inspiration.

Silberstein-Storfer, Muriel, with Moblen Jones. *Doing Art Together: The Remarkable Parent-Child Workshop at the Metropolitan Museum*. New York: Touchstone, 1983. For students, teachers, and parents. Based on the parent-child workshops at the museum, this books offers a feast of art projects, carefully explained with illustrations.

Sullivan, Charles, ed. *Imaginary Gardens: American Painting and Art for Young People*. New York: Harry N. Abrams, 1989. All grades. This volume will further your enjoyment of poems and paintings by American poets and painters. The images in the poems are often echoed in the paintings.

INDEX

ABOUT THE AUTHORS

JAN GREENBERG is a writer, a teacher, and an art educator, who directed the Aesthetic Education Master of Arts in Teaching program at Webster University in St. Louis. She is also the author of a number of books for young readers. She lives in St. Louis.

SANDRA JORDAN is a writer and photographer. For many years she was an editor of books for young readers. Sandra Jordan lives in New York City.